EGON SCHIELE

27 MASTERWORKS

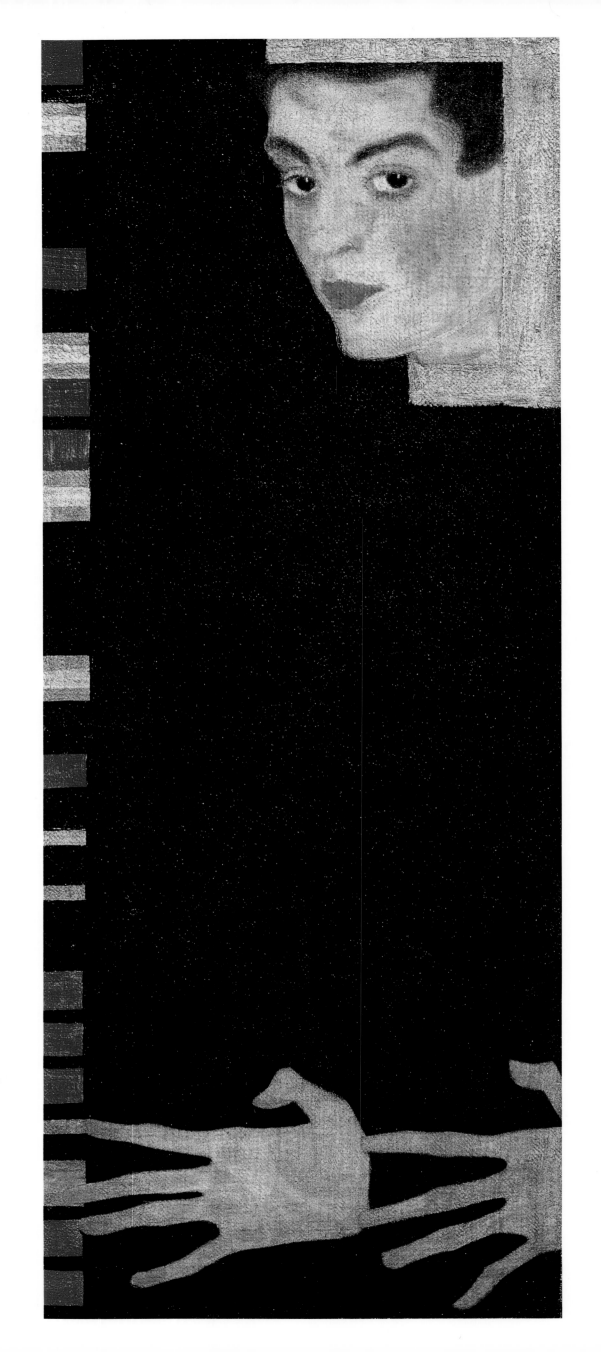

Egon Schiele

27 MASTERWORKS

Jane Kallir

Harry N. Abrams, Inc., Publishers

I would like to convey my warmest thanks to Hildegard
Bachert for her advice and assistance in the preparation of
this manuscript.
J. K.

The principal source for the information and quotes used herein
is Jane Kallir's *Egon Schiele: The Complete Works* (New York:
Harry N. Abrams, Inc., 1990). Artworks by Egon Schiele cited in
the text and captions are referenced according to their
catalogue raisonné numbers in that volume. The designation
"signed" means signed with the artist's full name; "dated"
means with the year only (e.g. "1910" or "10"); other signatures
and inscriptions are transcribed verbatim to the extent possible.

Project Director: Margaret L. Kaplan
Designer: Ellen Nygaard Ford
Photo Editor: Barbara Lyons

Frontispiece:
Self-Portrait with Spread Fingers. 1909. Oil and metallic paint on
canvas, 28$\frac{1}{8}$ x 10$\frac{7}{8}$" (71.5 x 27.5 cm). Kallir P. 153. Private collection

Front Cover:
Seated Woman with Left Hand in Hair. Detail. 1914. Gouache and pencil
on paper, 19$\frac{1}{8}$ x 12$\frac{3}{8}$" (48.5 x 31.4 cm). Signed and dated, lower left.
Kallir D. 1592. Graphische Sammlung Albertina, Vienna; Inv. 31.119.
(See page 64 for full image)

Back Cover:
Self-Portrait with Hands on Chest. 1910. Gouache, watercolor, and
charcoal on paper, 17$\frac{3}{8}$ x 12$\frac{1}{4}$" (44.8 x 31 cm). Initialed "S," lower right.
Kallir D. 693. Private collection

Library of Congress Catalog Card Number: 95-81775
ISBN 0-8109-2662-8

ILLUSTRATIONS

Egon Schiele

 ver the course of the last twenty-five years, Egon Schiele, whose initial rediscovery was in part an outgrowth of the 1960s counterculture, has acquired an enduring international following. The reasons for his continued popularity are multifaceted and point to the ongoing reevaluation of the modernist tradition that is underway as the twentieth century draws to a close. Many have noted parallels between the romantic pessimism prevalent in the waning years of the Austro-Hungarian empire and our own *fin de siècle*. A pervasive sense of doom, a preoccupation with mortality, and even the resurgence of sexually transmitted diseases, whereby the syphilitic scourge to which Schiele's father succumbed becomes analogous to the AIDS plague—all conspire to give Schiele's preoccupations contemporary resonance. Whereas his innate iconoclasm was at one time perceived as a mere precursor to the youthful rebellion of the 1960s, today his unnerving imagery evokes a more wide-ranging sense of malaise. In purely aesthetic terms, Schiele's failure to fit comfortably within any one stylistic school or movement also makes him the ideal artist for an age that eschews the logical, linear analysis previously thought to govern the development of modernism.

Austria's position within the maelstrom of twentieth-century cultural and political history is extremely ambiguous: at once central and off the beaten track. The small nation that came into being after 1918, almost wholly devoid of international presence, was easily subsumed into Hitler's *Reich* in 1938. On the losing side in both world wars, Austria was further obscured by a tendency to write history from the perspective of the victor nations. In art, this meant that the trajectory of modernism was traced from prewar France to postwar America, with an overriding emphasis on formalist innovations. Germany's more figural Expressionism was grudgingly acknowledged but never embraced. Austrian modernism—which combined Expressionist elements with traces of Symbolism and Art Nouveau—was for many years wholly ignored in the West.

This began to change gradually in the 1970s, as American and British scholars woke up to the bizarre concentration of multifaceted talents who had occupied the Viennese capital in the first two decades of this century. *Fin-de-siècle* Vienna has since acquired legendary status in interdisciplinary cultural studies. Where else can one find, working simultaneously, such figures as Sigmund Freud, Ludwig Wittgenstein, and Arnold Schoenberg? And were Vienna's role as the birthplace of psychoanalysis, modern linguistic philosophy, and atonal music not enough, one can add to these figures the names of Gustav Mahler and of Schoenberg's disciples Anton von Webern and Alban Berg; the writers Hugo von Hofmannsthal, Karl Kraus, and Robert Musil; the architects Otto Wagner, Josef Hoffmann, and Adolf Loos—on and on, seemingly ad infinitum. Vienna was of course always known for its music, and philosophical or scientific ideas, like music, travel relatively easily. Austria's contributions to modern literature have by comparison held up less well in translation, while architecture and art proved even more difficult to export. Nevertheless, Austria's peculiar brand of modern art did not acquire its luster solely by association with the nation's contemporaneous achievements in other realms. Once the fine arts came under closer scrutiny, it became evident

that they were pivotal to twentieth-century sensibilities not in spite of but precisely because of the fact that they did not fit seamlessly into the broader narrative of European modernism.

Histories of modern Austrian art generally begin with the architectural boom that swept Vienna in the second half of the nineteenth century. During this period of strong economic growth, the Emperor Franz Josef constructed a necklace of public edifices along the broad Ringstrasse that encircles Vienna's inner city, prompting artists to flock to the capital from all over to compete for decorative mural commissions. The most renowned painter of the era was Hans Makart, but the young Gustav Klimt also earned his reputation executing commissions on the interior walls of structures such as theaters and museums. The favored style combined a sort of blowsy eroticism (titillating but never explicit) with a firm grip on classical and historical allegory. Klimt gradually moved away from the accepted formula, however, evolving a personal symbolism that was less conventionally readable as well as more overtly sexual. This combination proved devastating so far as the tastes of staid Vienna were concerned: Klimt was banished from the ranks of public muralists, and henceforth had to seek support solely from well-heeled private patrons. As cofounder and first president of the Vienna Secession (an exhibition society that at the turn of the century included all the leading members of the avant-garde), Klimt remained the most successful artist of his day. Nonetheless, being exiled from the public to the private sector rankled him for the rest of his life.

Egon Schiele was born into this peculiar atmosphere on June 12, 1890. With public patronage on the wane and the commercial gallery system still in its infancy, Klimt and his colleagues had cobbled together a fairly impressive network of private patronage, capable of financing not only the Secession's magnificent exhibition hall, but the efforts of the notoriously inefficient Wiener Werkstätte (Vienna Workshop), a design collective that endeavored to unite the fine and the applied arts. The Secession's showings of foreign art introduced to Vienna a rather skewed view of modernism, one that placed more emphasis on international Symbolism than on the French Impressionism which had such a decisive influence almost everywhere else in Europe. Edvard Munch and Vincent van Gogh, rather than Edouard Manet and Claude Monet, became the dominant role models. This caused Austrian art to grow ever more brooding and introspective just at the moment when its financial support system was in a state of extreme flux.

All his life, Schiele yearned to create the sort of grand allegorical murals that Klimt had once painted, but there was no public outlet for such works and private clients rarely bought them. Unlike Klimt's society portraits, those painted by Schiele and his Expressionist colleagues were unflattering, and few patrons were eager for sittings. Thus a huge void developed between Schiele's artistic desires and his realistic prospects—a gap that was to haunt his entire brief career.

Schiele's family environment was not particularly encouraging for a fledgling painter. Adolf Schiele, the artist's father, was the stationmaster in the small town of Tulln, about eighteen miles west of Vienna, and it was expected that his firstborn son would follow him into railroad service. Little Egon's obsession with drawing trains—

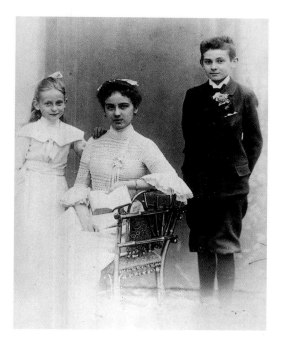

Fig. 1. Gertrude, Melanie, and Egon Schiele as Children. c. 1903. Photograph. Courtesy Alessandra Comini

which supposedly began at the age of one-and-a-half—led Adolf to hope that his son might become an engineer. Certainly he never dreamed the boy would instead want to be an artist, or, for that matter, considered this a fitting career. Education being fundamental to a bourgeois profession, Schiele was sent off at the age of eleven to attend a *Realgymnasium* in the town of Krems, some twenty-five miles distant from Tulln. The boy's loneliness (he was forced to board with an unsympathetic widow) and general lack of interest in academic subjects, however, made of him a poor student. Private tutors and a different *Gymnasium* (this one nearer to Tulln, in Klosterneuburg) did nothing to reverse the situation. Indeed, by the time Egon was fourteen or fifteen, he had been left back several times and was some two or three years older than most of his classmates. Matters were hardly helped by the death in 1904 of Adolf from syphilis, which he had contracted around the time of his marriage.

The circumstances of Adolf Schiele's illness precipitated a drastic drop from the family's previously middle-class station. Several years of increasing madness and supposedly the loss of all his savings preceded the father's death. Marie Schiele, his widow, was forced to turn to wealthier family members for assistance, in particular to her brother-in-law, Leopold Czihaczek, who became coguardian of the two minor children, Egon and his younger sister, Gertrude (Gerti). An older sister, Melanie, went to work for the railroad in order to augment the family's finances. Marie was encouraged by all her relatives to consider Egon's artistic ambitions woefully impractical—indeed, selfish and inconsiderate. Yet he was doing worse than ever at the *Gymnasium,* and toward the end of the spring semester in 1906, his teachers politely suggested he leave. With this, all thoughts of an engineering career—or any profession requiring a university education—had to be abandoned. Egon now prevailed upon his mother and Czihaczek to permit him to apply to the prestigious Vienna Academy of Fine Arts. That summer, he took and passed the rigorous entrance exam—becoming, at sixteen, the youngest student admitted to his class.

Though passionate about art, Schiele proved surprisingly resistant to the strict regimen at the Academy of Fine Arts. Certainly he was a brilliant draftsman, capable of executing in minutes assignments his classmates slaved over for hours. Yet there is something ponderous and heavy-handed about Schiele's early academic studies of antique casts and his relatively soulless renderings of professional models. It is not impossible to understand why his professors never gave him a grade higher than "satisfactory" (the equivalent of an American "C") for these efforts, particularly as the student's attention began to focus increasingly outside the classroom. The influence of Gustav Klimt became somewhat evident in the younger artist's work around 1907 (when Schiele supposedly met his would-be mentor), and emerged full-blown in 1908, presumably in the wake of a large exhibition, the "Kunstschau" (Art Show), which included a roomful of Klimt's paintings. By 1909, Schiele was strutting about Vienna calling himself the "Silver Klimt," and, in flagrant defiance of Academy regulations, had accepted invitations to exhibit at a second "Kunstschau" and at a commercial gallery, the Kunstsalon Pisko. Declaring their opposition to the Academy's rigid rules and orthodox methods in a formal letter of protest, Schiele and a group of like-minded classmates, the self-styled Neukunstgruppe (New Art Group), withdrew from the school in the spring of 1909.

Two portraits of Neukunstgruppe colleagues, Anton Peschka (fig. 2) and Karl Zakovsek (fig. 3), tellingly illustrate the transformation which Schiele underwent within a year of leaving the Academy. The Peschka painting, one of three that Schiele exhibited at the 1909 "Kunstschau," is still clearly marked by Klimt's example in its use of decorative patterning and in the sitter's triangulated profile pose. In the Zakovsek portrait, on the contrary, the subject confronts us head-on and the background has been stripped of all mollifying decorative fill: The world-weary gaze of this twenty-two-year-old man and his blank surroundings tell us that we have come face-to-face with the modern existential void. Schiele, eschewing the evident contradiction between Klimt's preoccupation with life-and-death subjects and his obsessive use of fidgety ornamentation, dispensed with the latter and went right to the core of the matter. He did retain from his mentor a reliance on elegant line, which however was now honed to an acute expressive sharpness. Indeed, Schiele's strongest point was his powerful mastery of line, and some have argued that for this reason his drawings and watercolors are actually superior to his oils.

By early 1910, Schiele appeared well on the way to establishing himself professionally. Not yet twenty years old, he had already developed his own distinctive Expressionist style and was amassing an impressive group of

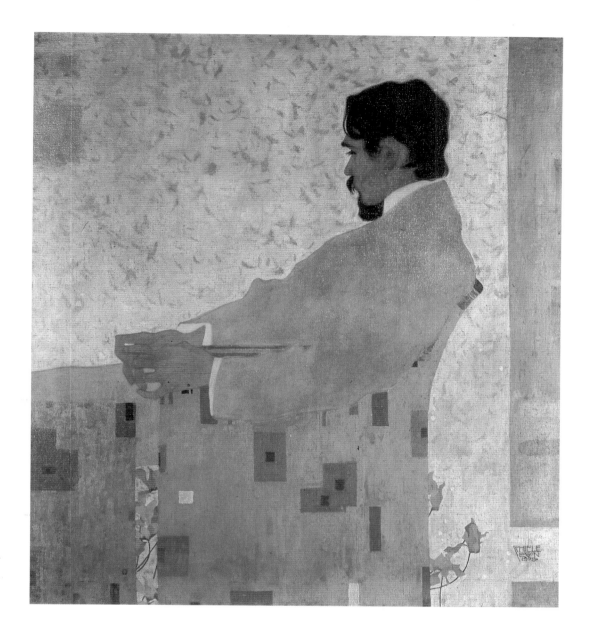

Fig. 2. **Portrait of the Painter Anton Peschka.** 1909.
Oil and metallic paint on canvas, 43$^3/_8$ x 39$^3/_8$"
(110.2 x 100 cm). Signed and dated, lower right.
Kallir P. 150. Private collection

Fig. 3. **Portrait of the Painter Karl Zakovsek.** 1910.
Oil, gouache, and charcoal on canvas, 39$^3/_8$ x 35$^3/_8$"
(100 x 89.8 cm). Initialed "S." and dated, lower left.
Kallir P. 160. Private collection

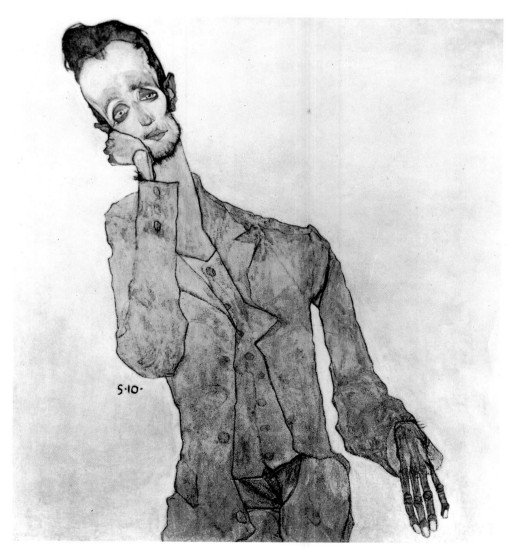

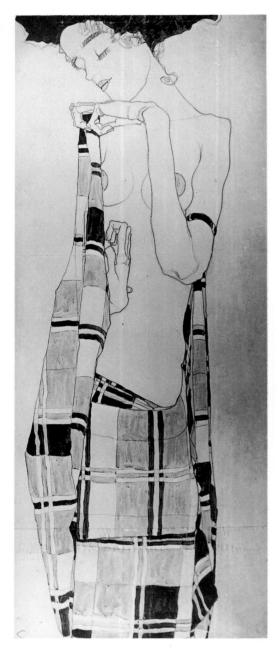

Fig. 4. **Standing Girl in Plaid Garment.** c. 1910. Watercolor and charcoal on cardboard, 52³/₄ x 20³/₄" (134 x 52.7 cm). Initialed "S," lower left. Kallir D. 541. The Minneapolis Institute of Arts, gift of Dr. Otto Kallir and the John R. van Derlip Fund, 1969; Inv. 69.7. The provenance and surviving correspondence suggest that this was a cartoon for a never-executed hammered-metal panel commissioned by the Wiener Werkstätte

supporters, including not just Klimt but also Klimt's Wiener Werkstätte colleagues, the art critic Arthur Roessler (plate 3), and a small cadre of well-to-do private collectors. So seemingly warm was his welcome into the avant-garde Viennese art establishment that his departure from the Academy could be seen less as an act of iconoclastic rebellion than as a smart career move. Schiele may at one point have seen it as such himself, but appearances proved deceptive. The example of Klimt and the Wiener Werkstätte had encouraged him to believe that artists are automatically entitled to societal support, regardless of their success or failure in the marketplace. Schiele was not inclined to be in the least accommodating, either professionally or personally. His decorative commissions for the Wiener Werkstätte—either too abrasive or too sexually explicit (see fig. 4)—almost invariably went awry, and his portraits were frontal assaults on a sitter's vanity. His profligate habits eventually exasperated his patrons—mostly older men, from whom Schiele expected a fatherly devotion that they were ill prepared to provide. Petty rivalries within the Neukunstgruppe soon forced the artist to confront the bitter truth: He would not automatically be anointed leader of his generation.

Schiele responded to these dashed hopes by turning inward and eventually fleeing Vienna. Toward the end of 1910, he began a series of murky allegories exploring his role as artistic visionary (fig. 5; see also plate 12). He was increasingly drawn to Krumau (plate 7), a beautiful medieval town in Czech Bohemia whose crumbling walls evoked for him the noble futility of human endeavor. Schiele had spent the summer of 1910 in Krumau, and in the spring of 1911, he decided to make a permanent move. At first, the artist was deliriously happy, taking the villagers' bemused looks as a sign of adulation. ("The children call me 'Lord God painter,' " he said proudly, in reference to the monklike caftan he habitually wore when working.) But the provincial villagers were, as it turns out, hardly impressed with Schiele's bizarre manner of dressing or, more to the point, with his unconventional life style. In August 1911, after a nude model was observed posing outdoors, he was evicted from his lodgings and forced to leave town. From the frying pan into the fire, Schiele now went to the Austrian village of Neulengbach where, in April 1912, he was jailed on charges of "public immorality" for allegedly exposing minors to erotic works in his studio (see plate 8).

The loss of the original court records, as well as the absence of much unassailable firsthand documentation of Schiele's imprisonment (other than a diary, the authenticity of which has been questioned), make it difficult to reconstruct fully the circumstances that preceded the artist's arrest. Obviously, his habit of inviting children to pose contributed to his predicament, although surviving drawings suggest that, especially in the smaller towns of Krumau and Neulengbach, his underage models rarely removed their clothes. Children clearly found the painter—who in many ways still thought and acted like a child himself—a romantic and appealing figure, and his Neulengbach studio quickly became an after-school hangout. Apparently, the trouble started when one of these girls, Tatjana Georgette Anna von Mossig, decided to run away from home and sought refuge with Egon and his lover, Valerie (Wally) Neuzil (plate 9). The couple, not knowing how to react, agreed to take the girl to her grandmother in Vienna the next day, but when they arrived in the city, Tatjana became frightened and asked to return home. All in all, she was gone three nights, but by the time her father came to fetch her, he had already filed charges of kidnapping and rape against Schiele. Tatjana would ultimately waffle in her testimony, and these charges would be withdrawn, but they prompted the local authorities to launch a full-scale investigation of the artist. A search of his studio revealed a single incriminating drawing tacked to the bedroom wall, which led to the count of public immorality on which Schiele was tried and convicted.

The twenty-four days that Schiele spent in jail formed a turning point in his brief life. Hereafter, he was gradually compelled to come to terms with the demands that society places on everyone, including artists. He made visible concessions to conventional morality almost immediately: He more or less stopped drawing children and in 1915 broke with Wally and married the bourgeoise Edith Harms (plate 20). Professionally, Schiele found it somewhat harder to get back on track. His imprisonment, coupled with his protracted absence from the Viennese art scene, had severed the already tenuous ties with many of his original patrons, and his innate independence tended to sabotage his fledgling relationships with commercial art dealers. After moving back to Vienna in 1912, Schiele's progress was

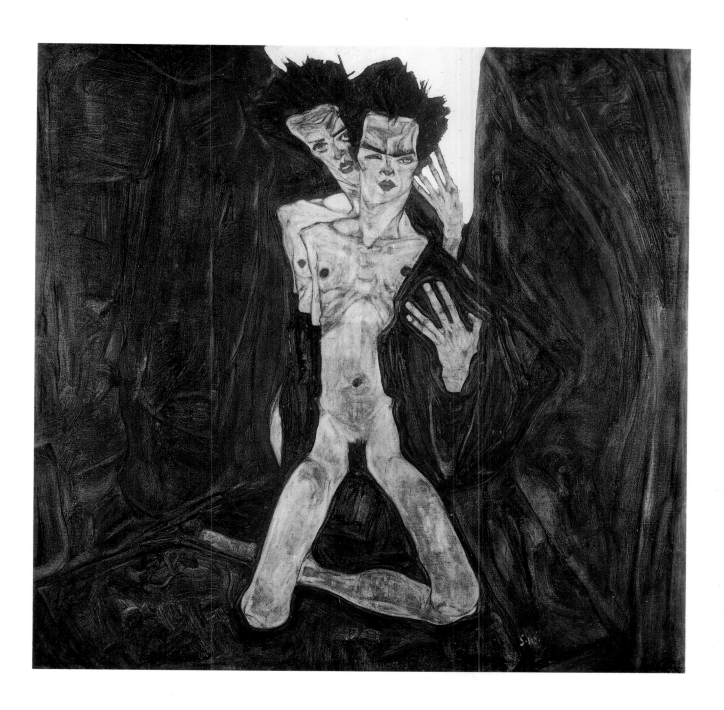

Fig 5. **The Self-Seers I.** 1910. Oil on canvas, 31 1/2 x 31 3/8"
(80 x 79.7 cm). Initialed "S." and dated, lower right.
Kallir P. 174. Present whereabouts unknown

further hampered by his insistence on creating large allegorical paintings (see fig. 18), but his exhibitions were receiving more favorable notice and he began to attract a new set of patrons, including the wealthy Lederer family (fig. 6; see also plate 13) and the generous collector Franz Hauer.

Schiele's personal path into adulthood was paralleled by changes in his artistic approach. As he grew less self-centered and more outward-looking, his art grew less anguished and introspective. The number of self-portraits diminished (though he remained obsessed with his role as artistic visionary), his line became smoother, his manner of modeling more overtly realistic (see plate 23). The female nude had always figured prominently in Schiele's work—as indeed it does in that of many artists. However, whereas in his early twenties he had explored his own ambivalence toward and even terror of sexuality (see plates 1 and 5), he now approached the subject from a greater emotional distance (fig. 7). His later nudes were increasingly depersonalized, but his portraits were, conversely, more probing. Instead of projecting his own personality onto that of his subjects, as he had formerly, he was now intimately attuned to each individual's identity.

The greater humanism of Schiele's later work was conditioned not only by his newfound maturity, but more concretely by his marriage and by his experiences as a soldier in the Austro-Hungarian army during World War I. His imminent induction into the army had escalated his flirtation with Edith Harms, whom the artist married four days before he was scheduled to report for basic training. The newlyweds' forced separation and Egon's (not entirely unjustified) jealous suspicions of Edith placed an early strain on their marriage. Yet Schiele's need to come to terms with his wife's failings gave him greater insight into the workings of the female psyche overall, as was evidenced in many of his subsequent portraits (fig. 8). He showed similar compassion toward the Russian prisoners of war (osten-

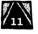

Fig. 6. **Portrait of Erich Lederer.** 1912. Oil and gouache on canvas, 54³/₄ x 21³/₈" (139 x 55 cm). Signed and dated, lower right. Kallir P. 235. Öffentliche Kunstsammlung, Basel, Kunstmuseum, gift of Mrs. Erich Lederer–von Jacobs in memory of her late husband, 1986; Inv. G 1986.16

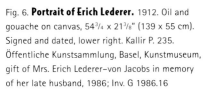

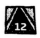

sibly his enemies) whom he was assigned to guard (fig. 9). "Their desire for eternal peace was as great as mine," he noted. Sensing nationalism's devastating potential, he was an avowed pacifist at a date when even so-called radicals still supported the war.

The war of course totally disrupted Schiele's professional life. After completing basic training, he spent some months stationed in and around Vienna, but even though the artist was often allowed to sleep at home, he could get little painting done. In May 1916, he was sent to the rural hamlet of Mühling, about three hours west of Vienna. His duties—mainly office work—were not particularly taxing, and since Mühling was not in a war zone, Edith was allowed to accompany him there. Nevertheless, the couple's life remained unsatisfactory—1916 was Egon's least productive year artistically, and Edith, bored and lonely, seems to have complained constantly. Considering that the Austro-Hungarian army provided privileged spots for many artists and writers, Schiele found it surprisingly difficult to wangle a post that would allow him to use his talents. Finally, in early 1917, he managed to get himself assigned back to Vienna, where under the sympathetic eyes of his superiors at the Military Supply Depot, he was given plenty of time to pursue his art.

Schiele returned to Vienna full of creative energy and eager to get his career moving again. Some of his plans—for example, for the establishment of an exhibition organization (which he called a Kunsthalle) modeled along the lines of the Secession—foundered, but on the whole he made remarkable strides. The director of the Staatsgalerie (today the Österreichische Galerie, or Austrian National Gallery), Franz Martin Haberditzl, acquired a number of works by Schiele and sat for a portrait. The first portfolio of Schiele reproductions was published by the book and art dealer Richard Lanyi, and commissions of all sorts began to roll in. Schiele also took the lead as an exhibition organizer, first for the Imperial Army Museum, and then in 1918 for the Secession. Schiele's own section at the Secession show was almost completely sold out, and though inflation ate into his earnings, the artist for the first time saw a prospect of affluence. In 1917 and 1918, he could at last afford a harem of models comparable to that routinely employed by Gustav Klimt. In the summer of 1918, Schiele rented a large garden apartment on the Wattmanngasse, retaining his old premises on the Hietzinger Hauptstrasse with the thought of opening an art school there. Since Klimt's death that past February, Schiele had been widely acknowledged as Vienna's foremost artist.

It is ironic that, with the entire world in a state of momentous transition, Schiele to the end cast himself in the antiquated mold of Gustav Klimt. Although private patronage had for most of his life provided Schiele with meager sustenance, he refused to embrace the wider marketplace that could only be reached under the auspices of a commercial gallery. Instead, with his new, more humanistic and palatable style, he set himself up to replace Klimt as a society portraitist. And while public patronage was doomed even in Klimt's day, Schiele spent a good portion of his last two years concocting a monumental mural scheme. How—if ever—this self-styled mausoleum was to have been built (or whose body it was intended to house) remains unclear. Evidently, however, most of the allegorical nudes which Schiele painted in late 1917 and 1918 were intended for its walls. His final masterpiece, *The Family* (fig. 10), was not (as is commonly thought) an autobiographical statement, but rather a metaphor for what Schiele, in his mausoleum notes, called "earthly existence." The male figure (a self-portrait representing the life force) hunches over the female (the vehicle) and the infant (the creative outcome). The three figures encompass a nested cycle of decay and regeneration.

Although *The Family* is not autobiographical (and the woman is an anonymous model), Egon and Edith did in fact conceive a child shortly after the painting was finished. There is surprisingly little evidence—either artistic or anecdotal—of how Schiele was affected by the prospect of fatherhood. While he was solicitous of his wife's health, his growing professional stature had if anything increased the emotional distance between them. In the autumn of 1918, an early cold snap and pervasive fuel and food shortages provided a fertile breeding ground for the deadly Spanish influenza epidemic that would eventually sweep Europe and the United States, claiming more victims than

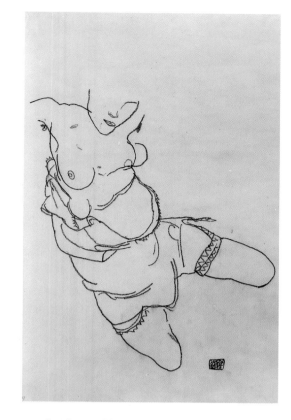

Fig. 7. **Foreshortened Study of a Model.** 1917. Charcoal on paper, 18³/₈ x 11³/₈" (46 x 29 cm). Signed and dated, lower right. Kallir D. 1957. The Metropolitan Museum of Art, New York, bequest of Scofield Thayer, 1982; Inv. 1984.433.307

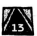

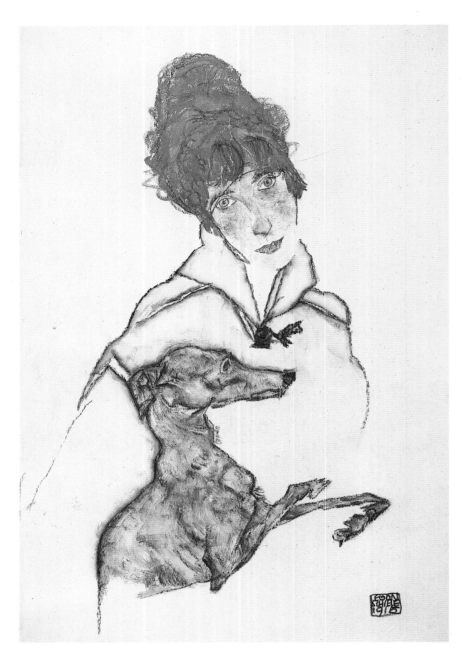

Fig. 8. **Woman with Greyhound (Edith Schiele).**
1915. Gouache and black crayon on paper, 19 1/2 x 12 3/8"
(49.5 x 31.5 cm). Signed and dated, lower right. Kallir D.
1710. Private collection

Fig. 9. **Russian Prisoner of War (Grigori Kladjishuili).**
1916. Gouache and pencil on paper, 19 x 12 1/8"
(48.3 x 30.8 cm). Signed and dated, lower right. Signed
by the subject [in Russian], upper right. (Verso Kallir D.
1449.) Kallir D. 1839. The Art Institute of Chicago, given
in memory of Gloria Brackstone Solow by Dr. Eugene
Solow and family; Inv. 1966.172

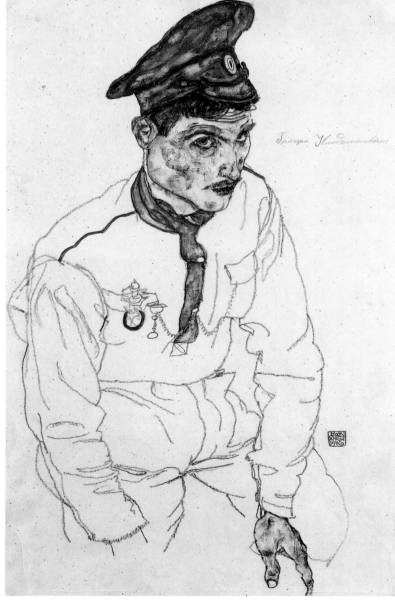

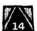

Fig. 10. **The Family (Squatting Couple).** 1918. Oil on canvas, 60 x 64" (152.5 x 162.5 cm). Kallir P. 326. Österreichische Galerie, Vienna; Inv. 4277

the world war. Edith, in her sixth month of pregnancy, contracted the disease a few days before her husband. She died on October 28; Egon followed on October 31.

The body of work which the twenty-eight-year-old Egon Schiele left behind is indelibly marked by the stamp of his youth. His earliest Expressionist pieces chart the universal adolescent search for personal and sexual identity, while the adoption of more conventional stylistic methods accompanies his growing maturity and acceptance of the role of husband and artistic leader. Although it is wrong to conflate Schiele's life with his art, the art probably *is* more strongly shaped by his personal development than is commonly the case. Unlike many modernists in other countries, Schiele did not have the support of a group of like-minded colleagues. Drawing creative sustenance from an eclectic smattering of foreign and domestic influences, he reached his ultimate formal solutions largely alone. So long as modern art history was written in terms of broad schools and movements, the idiosyncratic achievements of an Egon Schiele could never receive proper recognition. Today, however, we are more inclined to recognize that history is a messy mass of loose ends, subject to myriad distortions and subjective biases. From this perspective, Schiele is very much a man of our times, just as his anguish and confusion reinforce our pervasive conviction that there are no easy answers to the existential dilemmas confronting us at century's end.

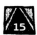

PLATE 1

Nude Girl with Folded Arms (Gertrude Schiele)

1910. Watercolor and black crayon on paper, 19¼ x 11" (48.8 x 28 cm).
Initialed "S," lower right. Kallir D. 516. Graphische Sammlung Albertina, Vienna;
Inv. 30.772. Study for *Standing Female Nude with Crossed Arms* (Kallir P. 169)

Prior to 1910, Schiele's work was strongly influenced by that of his mentor, Gustav Klimt. Other Viennese artists—notably Oskar Kokoschka and Schiele's friend Max Oppenheimer—began executing Expressionistic work (chiefly portraits) around 1909. When Schiele suddenly emerged with an Expressionistic idiom in early 1910, however, there was little evidence that he had been influenced by either Kokoschka or Mopp (as Oppenheimer was commonly called). The somber, murky colors used by the latter artists were distinctly different from Schiele's ebullient palette, and the jerky primitivism of Kokoschka's rendering was totally at odds with Schiele's elegant virtuosity. Schiele's refined lines derived in part from his academic training, and in part from Klimt's legacy, but no Austrian precedent can be found for the brilliant reds, luminous yellows, and poison greens that dominate so much of Schiele's work in the first months of 1910.

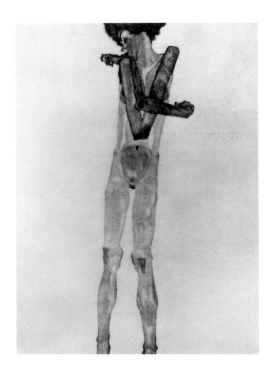

Fig. 11. **Standing Female Nude with Crossed Arms (Gertrude Schiele).** 1910. Oil on canvas, 59 x 59" (150 x 150 cm). Kallir P. 169. Present whereabouts unknown

Schiele's earliest major artistic statement was a series of five large nudes: two females (see fig. 11) and three males. The subjects were, respectively, the artist's sister Gerti and Schiele himself. Only one of these canvases survives, and the related studies are thus our most reliable guide to the series as a whole. In a complete break with Klimt, Schiele entirely eliminated any sort of decorative background, and with it all mollifying context and protective cover. The figure was left alone to confront her or his most intimate fears and desires. In the depictions of Gerti, the model's evident shyness (which was confirmed by her own recollections of these sessions) and the artist's uneasiness with the opposite sex became inextricably entangled. Those body parts that Gerti herself did not conceal with her crossed arms were disguised by Schiele's androgynous interpretation. The nude series is essentially an exploration of emergent sexuality as well as of Schiele's own ambivalent erotic feelings.

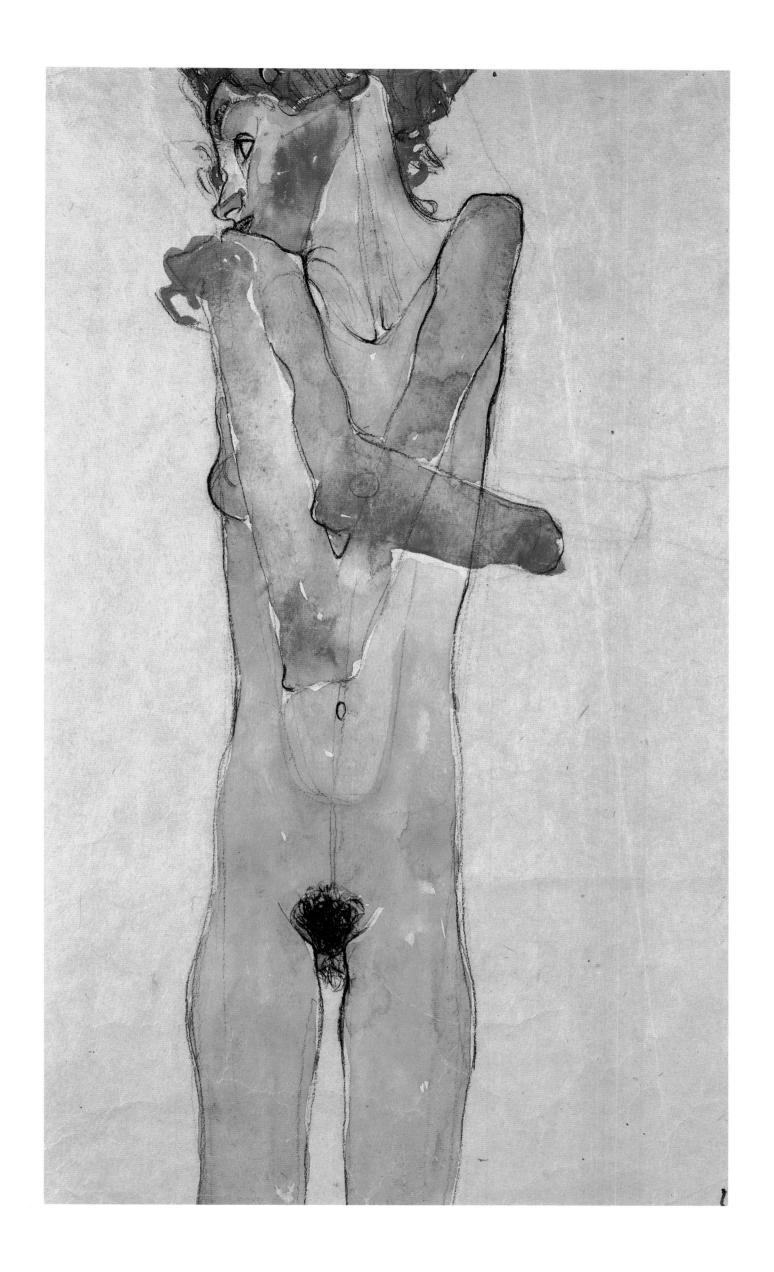

PLATE 2

Self-Portrait with Hand to Cheek

1910. Gouache, watercolor, and charcoal on paper,
17¹/₂ x 12" (44.3 x 30.5 cm). Signed "Schiele" and dated, lower left.
Kallir D. 706. Graphische Sammlung Albertina, Vienna; Inv. 30.395

It has been said that Schiele painted and drew more self-portraits than almost any other artist who ever lived, with the exception of Rembrandt. Though he had done self-portraits as a boy, the subject became increasingly important in 1909 (see frontispiece) as he began to find his artistic identity. Particularly during these early years, when Schiele was just starting out, he was his own cheapest and most available model. But financial hardship has plagued many artists, and this was not the sole reason Schiele depicted himself so frequently between 1909 and 1911. The numerous self-portraits that he executed during these years as well as later were part of a postadolescent process of identity formation.

Schiele's self-portraits record a multitude of possible selves. While his contorted and anguished images have tended to attract the most notice, there are a good number of others in which the artist presented himself in more elegant or serene guises (see back cover). In all these works, Schiele simultaneously conducted and recorded his own psychological biopsy; he was both vehicle and emblem. With fearless virtuosity, he combined equal parts agonized introspection and self-conscious posturing. Strikingly, each element prevents the other from going to excess, so that the self-portraits successfully skirt the very real dangers of bathos and mannerism.

Perhaps influenced by his friend the mime Erwin van Osen, Schiele was developing an idiosyncratic and highly expressive language of gesture. Here he puffs out his chest, there he pulls down an eyelid, and then again his hair stands on end as though electrified by a high-voltage shock. At one moment, he basks in newfound sexual potency; the next, he is horrified by his physical desires. Now he struts forward, and then again, he pulls back in evident terror. Haunted by death, yet driven by a passion for life, Schiele in these works reveals both vulnerability and bravado. It is here, above all, that his dualism—his ability to embody contradictions—is most eloquently expressed.

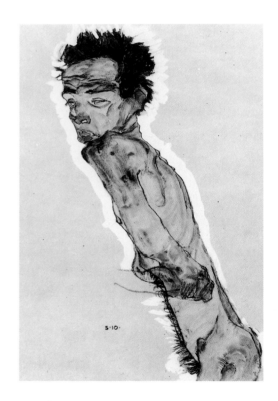

Fig. 12. **Male Nude in Profile, Facing Left (Self-Portrait).**
1910. Gouache, watercolor, and black crayon on paper,
17 x 10⁷/₈" (43.1 x 27.5 cm). Initialed "S," and dated, lower left. Kallir D. 707. Graphische Sammlung Albertina, Vienna; Inv. 23.599

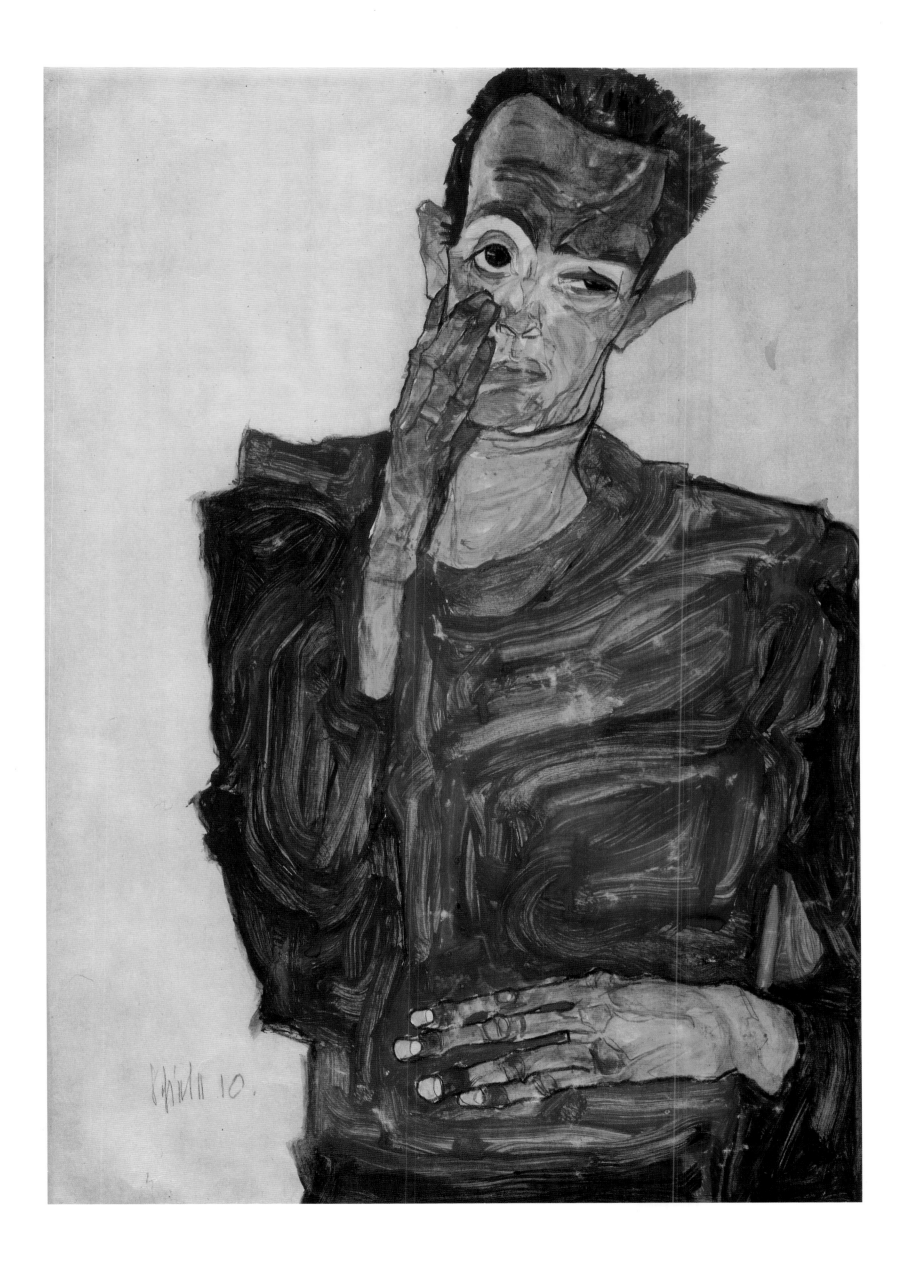

PLATE 3

Portrait of Arthur Roessler

1910. Oil on canvas, 39 1/4 x 39 1/4" (99.6 x 99.8 cm).
Initialed "S." and dated, center left. Kallir P. 163.
Historisches Museum der Stadt Wien; Inv. 78951

Arthur Roessler was one of Schiele's most ardent champions and patrons, a relationship that endured, with sporadic ups and downs, throughout the artist's career and perhaps reached its apogee after his death, when Roessler became his first biographer and memoirist. Within the small and relatively unsophisticated prewar Viennese art world, Roessler wore a number of hats. He is best remembered as the art critic of the socialist *Arbeiter-Zeitung,* though he also penned a number of volumes about artists whom he favored. He dabbled as well at dealing, serving for a time as artistic adviser to the Galerie Miethke. For Schiele, he was no ordinary supporter. Not only did he promote the artist in the press and personally buy his work, he also established connections with other collectors and dealers. He was, so to speak, Schiele's de facto agent, though the relationship was never spelled out and sometimes there were misunderstandings about Roessler's proper compensation.

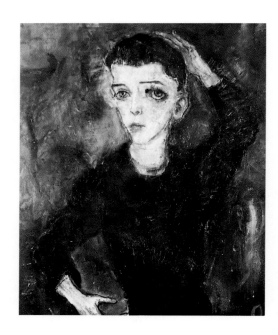

Fig. 13. Oskar Kokoschka. **Boy with Raised Hand.**
c. 1909. Oil on canvas, 27 1/2 x 25 5/8" (70 x 65 cm).
Initialed, lower right. Private collection

The *Portrait of Arthur Roessler* typifies a stylistic shift which Schiele experienced in the later months of 1910. For the first time, the influence of Max Oppenheimer and Oskar Kokoschka (see fig. 13) becomes readily apparent: The palette is more subdued, the paint surface more consciously rubbed and scraped. Nonetheless, there are distinct differences in the methods whereby Kokoschka, Mopp, and Schiele achieved their superficially similar effects. Kokoschka's approach is reductive: Paint is applied in bold swathes that are then partially pared away, sometimes down to the bare canvas, so that the subject appears to float wraithlike to the surface. Mopp's technique is more conventionally additive, his paint surface somewhat denser. Schiele, for his part, remains a watercolorist at heart. The Roessler painting is structured like a large drawing in its disposition of the figure on the picture plane, in its use of negative space, and in the tensile correlation between the surface brushstrokes and the figure's boundaries.

Roessler's portrait is in some respects curiously similar to the depictions of Gerti that Schiele created earlier the same year (compare plate 1). The pose, with its crossed arms and deflected gaze, is nearly identical to that in one of the large nude paintings and several of the watercolor studies. Just as Schiele was cowed by the force of his sister's sexuality, he may have been in awe of this seemingly powerful older man. The artist surely viewed Roessler as a magical "fixer," capable of solving or arranging just about anything. At least at this early stage in their friendship, it behooved Schiele to maintain a respectful distance.

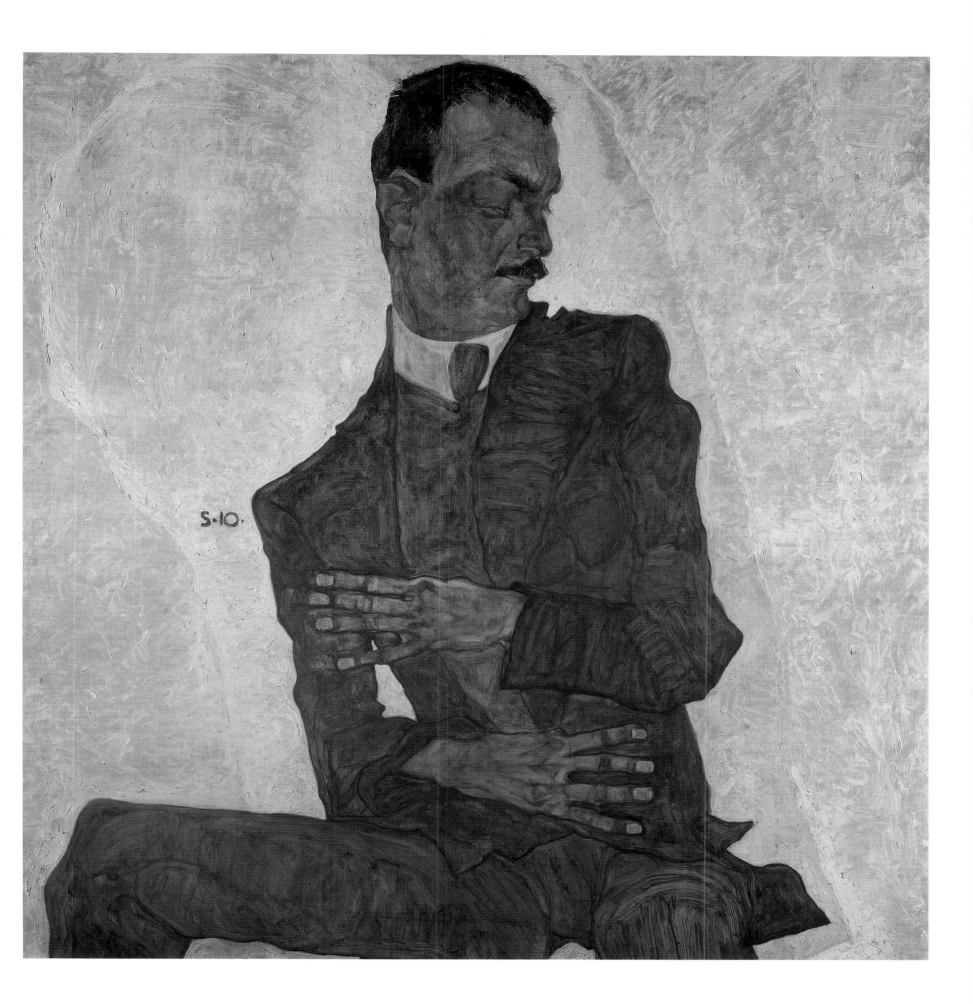

PLATE 4

Two Little Girls

1911. Gouache, watercolor, and pencil on paper,
15³/₄ x 12" (40 x 30.6 cm). Signed and dated, center right.
Kallir D. 761. Graphische Sammlung Albertina, Vienna; Inv. 27.945

Schiele, in his early twenties, tended to gravitate to the familiar. He himself, his beloved sister Gertrude, and his fledgling girlfriends were his most frequent models. He also readily identified with children. The artist, who described himself as an "eternal child," was in many ways still a boy himself. Certainly his emotional maturity lagged far behind his artistic precocity, making it possible for him to depict puerile mental states that generally elude older artists. The torment of growing up remained very real to him; not only did he still suffer the pangs of puberty, but he found young models far less intimidating than adults.

Children had one other great advantage over mature models in Schiele's early, impecunious days: they could be persuaded to pose for spare change, or even for a bit of candy. The streets of Vienna were teeming with young urchins, and Schiele lured them like the Pied Piper. His friend the artist and writer Paris von Gütersloh gave the following description:

> There were always two or three smaller or larger girls in [Schiele's] studio; girls from the neighborhood, from the street, solicited in nearby Schönbrunn Park; some ugly, some attractive, some washed, but also some unwashed. They sat around doing nothing. . . . Well, they slept, recovered from parental beatings, lolled about lazily (which they were not allowed to do at home), combed . . . their closely cropped or tangled hair, pulled their skirts up or down, tied or untied their shoelaces. And all this they did—if one can call that doing something—because they were left to themselves like animals in a comfortable cage, or so they perceived it.

Though Schiele did not shy away from depicting his underage subjects in the nude, it must be said that most of his drawings of children were quite chaste.

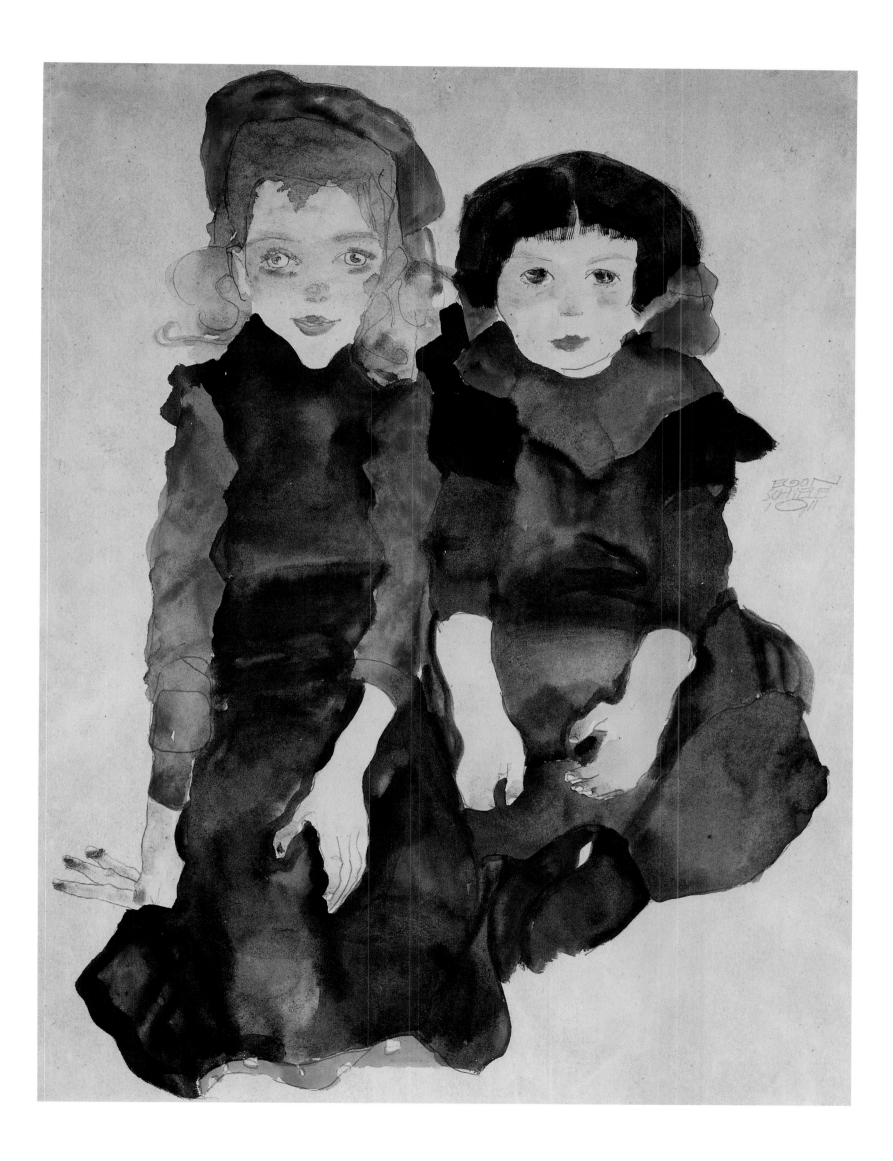

PLATE 5

Nude Girls Reclining

1911. Watercolor and pencil on paper, 22^1/$_4$ x 14^1/$_2$" (56.5 x 36.8 cm).
Signed and dated, lower right. Kallir D. 884. The Metropolitan Museum of Art, New York.
Bequest of Scofield Thayer, 1982; Inv. 1984.433.309

Schiele's nudes have attracted a disproportionate degree of attention despite the fact that these works are no more numerous or even for the most part more sexually explicit than those of many other artists (for example, Pablo Picasso or Auguste Rodin). One reason for the prevalent focus on Schiele's eroticism may be that, particularly in his earlier nudes, the artist tended to ignore the aesthetic conventions that had been developed over the ages to neutralize and distance such potentially volatile subjects. He granted more autonomy and respect to female sexuality than is the norm among male artists even today, while at the same time remaining on the whole baffled (indeed, often terrified) by women.

Little is known of Schiele's personal sexual experiences in 1910 and early 1911. Certain faces recur frequently among his models, and it is clear from some of the drawings that Schiele had relations with at least one of these young women. Surviving correspondence indicates that in the summer of 1910, an adolescent boy developed a crush on the slightly older artist, but it is also evident that Schiele fled from the prospect of a full-fledged homosexual affair.

The status of the models in *Nude Girls Reclining* is ambiguous, and perhaps intentionally so. They may have just been lolling about Schiele's studio, or perhaps they had recently engaged in sex. They are, in either event, wholly lost in their own self-contained world. The pillows and drapery that envelop the figures like a cocoon typify a compositional device that Schiele characteristically employed in 1911. In general, the artist preferred blank backgrounds in both his paintings and his drawings, and he was a master at manipulating the negative space surrounding a subject. However, perhaps in connection with an attempt to create more complex allegorical canvases, Schiele in 1911 began to break his backgrounds down into pseudo-Cubistic geometric nuggets. While this formal device was largely dropped thereafter from his works on paper, it was sporadically employed in his oils for several years to come (see plate 12).

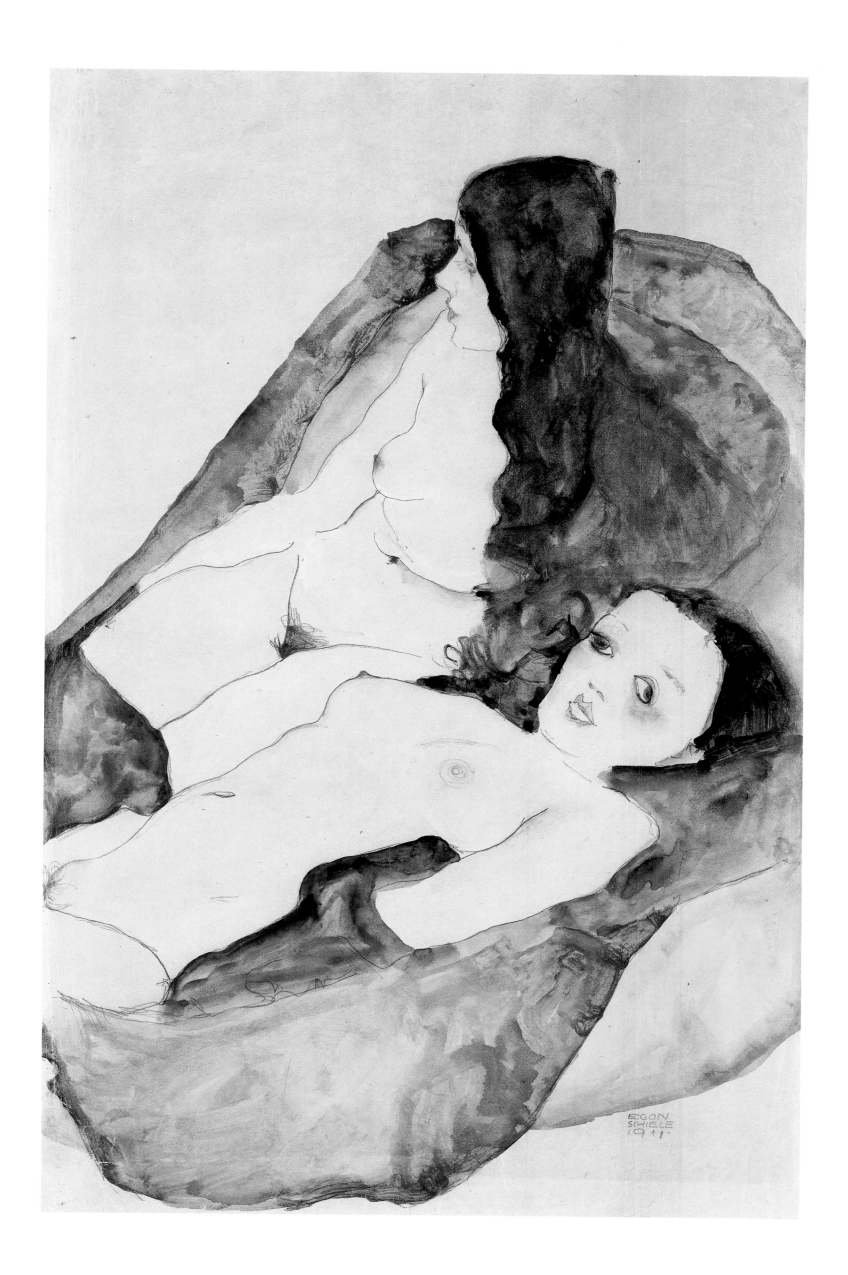

PLATE 6

Sunflowers

1911. Watercolor and pencil on paper, 17 1/8 x 11 1/2"
(43.5 x 29.3 cm). Signed and dated, center right. Related to
the painting of the same subject (Kallir P. 221). Kallir D. 985.
Graphische Sammlung Albertina, Vienna; Inv. 27.947

Schiele's choice of the sunflower as a motif undoubtedly owed something to the precedents set by Vincent van Gogh and Gustav Klimt. Van Gogh's sunflowers had been popular in Vienna ever since the artist's work was first exhibited there in the early years of the twentieth century. Shortly after a 1906 Van Gogh exhibition at the Galerie Miethke, Klimt painted two pictures of the subject, both of which were shown at the large "Kunstschau" (Art Show) held in Vienna in 1908.

Schiele, who undoubtedly knew Klimt's sunflower paintings in the original and was familiar with those of Van Gogh from reproductions if not from direct contact, nevertheless brought his own interpretation to the subject. Van Gogh's canvases tended to depict formal flower arrangements in vases (fig. 14), while Klimt's sunflowers were shown in nature, surrounded by suffocatingly dense botanical life. Like Klimt's sunflowers, Schiele's appear in their natural state, with fat stalks and leaves still attached. However, as was the younger artist's wont, the background has been left vacant, so that the flowers, lacking any mollifying context, represent elemental entities in and of themselves.

For all three artists, the sun and its earthly counterpart, the sunflower, were embodiments of the life force. Nonetheless, unlike the sun, the sunflower is mortal, and for Schiele it was tinged with the indelible mark of imminent decay. Flowering in the last warm days between summer and autumn, the sunflower blooms to die and bequeath the world its seeds. That Schiele's sunflowers are past their peak bloom is amply evidenced by their darkened centers and droopy leaves. This was the ideal motif for an artist who had coined the maxim "Everything is living dead."

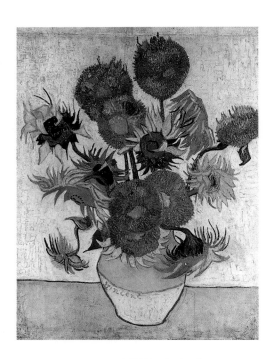

Fig. 14. Vincent van Gogh. **Still Life with Sunflowers.** 1889. Oil on canvas, 37 7/8 x 28 3/4" (95 x 73 cm). Signed and dated, lower center. Rijksmuseum Vincent van Gogh, Amsterdam

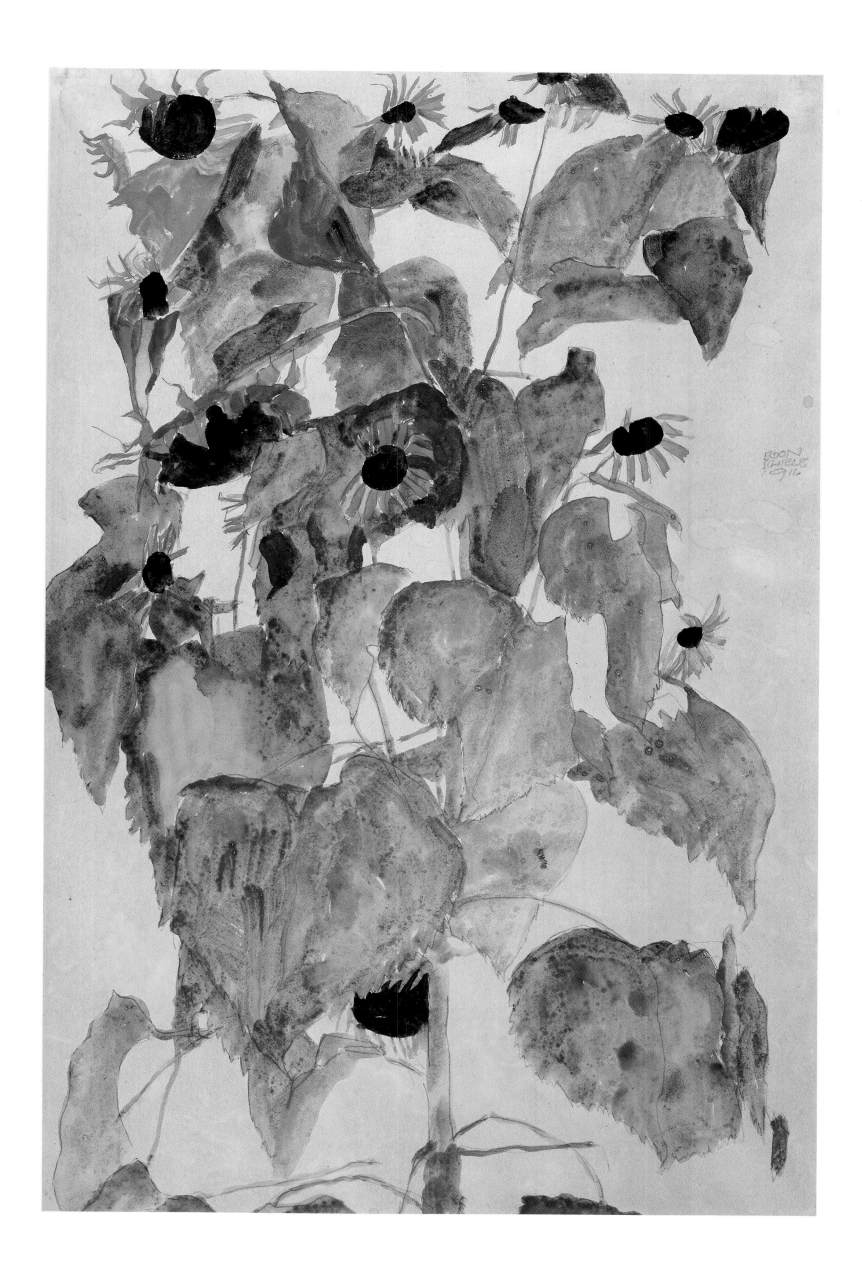

PLATE 7

The Old City I (Dead City IV)

1912. Oil on wood, 16³/₄ x 13³/₈" (42.5 x 34 cm).
Signed and dated, lower left. Kallir P. 245. Private collection

Schiele's favorite landscape subject, by a wide margin, was the town of Krumau (Çesky Krumlov in today's Czech Republic), referred to by him most frequently as the "Dead City" (but also as the "Old City" and the "City on the Blue River"). Krumau, his mother's birthplace, was undisputedly an old city, a medieval time capsule whose winding streets and crumbling buildings embodied for Schiele the eternal interplay of human persistence and decay. Situated around and within a tortuous bend in the Moldau River (now called the Vlatava), Krumau has a compact, islandlike configuration that Schiele found compositionally intriguing. He liked especially to perch on the high left bank of the river and draw the old town from above. He told one friend that this bird's-eye perspective influenced all his work, and indeed, even his nudes were often viewed from the vantage point of a tall stool or ladder.

Krumau was both spiritually and aesthetically satisfying for Schiele. This was a haunted town—haunted by the many generations (including Schiele's ancestors) who had lived and died within its ancient walls, and haunted specifically by the artist's father, who had once unsuccessfully attempted suicide there and whose ghost supposedly appeared before the artist during a 1910 visit. As depicted by Schiele, Krumau was a barren, unpopulated town, a beautiful reminder of a long-dead past, a shell whose creators and inhabitants had long ago perished.

All his life, Schiele was inspired by what he termed the "Cubistic" quality of certain towns—that is, by their rectilinear geometry—and Krumau was highly qualified in this regard. This was at heart an ersatz Cubism, one in which structures were arranged like building blocks along a child's railroad set or snapped together like the abstract pieces in a jigsaw puzzle. Schiele's vision was fundamentally two-dimensional: distances are foreshortened or flattened, and forms are described by brushwork rather than volumetric modeling. In the Krumau townscapes, walls, streets, river, and sky link together to create an unbroken continuum of shapes. It is a tight, airless network that is in some ways the exact opposite of the wide-open voids of Schiele's figure pieces. At the same time, the claustrophobia of the Krumau compositions ideally evokes the artist's vision of this doomed yet enchanting little city.

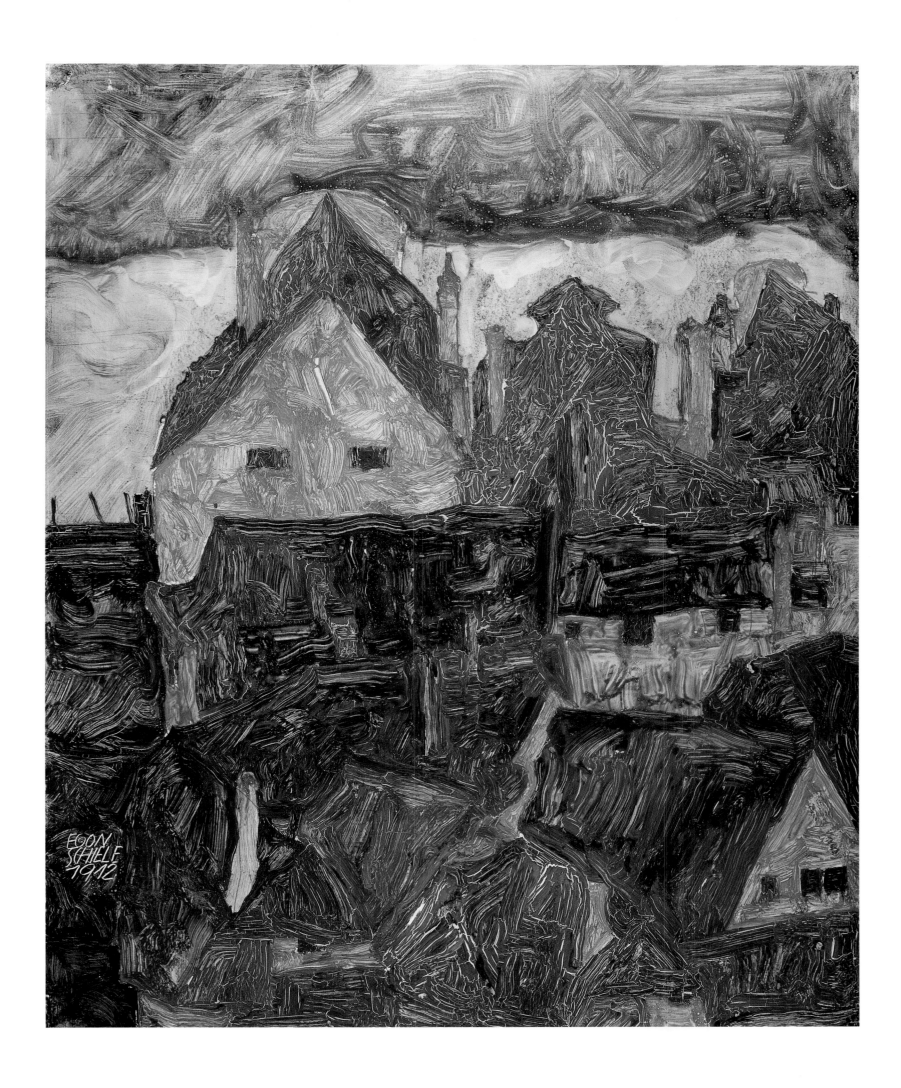

PLATE 8

Hindering the Artist Is a Crime, It Is Murdering Life in the Bud!

1912. Watercolor and pencil on paper, 19⅛ x 12½" (48.6 x 31.8 cm).
Signed, dated "23.IV.12. D.," and inscribed "Den Künstler hemmen ist
ein Verbrechen, es heisst, keimendes Leben morden!" lower right. Kallir
D. 1186. Graphische Sammlung Albertina, Vienna; Inv. 31.162

Schiele's inner-directed search for self, coupled with virtual obliviousness to the impact of his outward behavior, put him on a collision course with societal mores. Encouraged by the examples of Gustav Klimt and the Wiener Werkstätte (an artist-run design collective) to believe that his position as an artist placed him beyond the pale of bourgeois custom while simultaneously entitling him to unquestioning support, he blithely pursued a Bohemian life style that was bound to raise eyebrows in the small towns, Krumau and Neulengbach, to which he gravitated in 1911 and 1912. It was not just that he dressed strangely (in modern suits of his own design or cloaklike caftans), or that he declined to go to church, or that his model/girlfriend Wally Neuzil slept over. Above all, Schiele's mistake lay in asking young children to pose, for even if (as was usually the case) they remained fully dressed, they were likely, in his studio, to come in contact with his more explicit work. Thus it happened that in April 1912, Schiele spent twenty-four days in prison for "offenses against public morality."

It is said that Schiele first received art supplies on April 16th, the third day of his imprisonment, but the earliest known drawing is dated the 19th. Over the course of the next three days, the artist created a series of watercolors meticulously recording his unnerving new surroundings: his cell, the passageway outside, and the chairs within (virtually the only objects of interest, out of which he fashioned ad hoc still lifes).

On April 23, Schiele started to draw self-portraits. He also at this time began to record on his drawings the day of the week (denoted by an initial) in addition to the date, suggesting an increasingly urgent need to keep track of the passage of time. Prior prison drawings had all been inscribed with descriptive phrases, but in the self-portraits the artist resorted to far more poetic formulations. "Hindering the artist is a crime . . ." is an eloquent summary of Schiele's attitude toward his predicament: Jailing an artist is an offense against life itself. Not he but his jailers were the criminals, for failing to recognize the sanctity of his mission and to give him free license to pursue it.

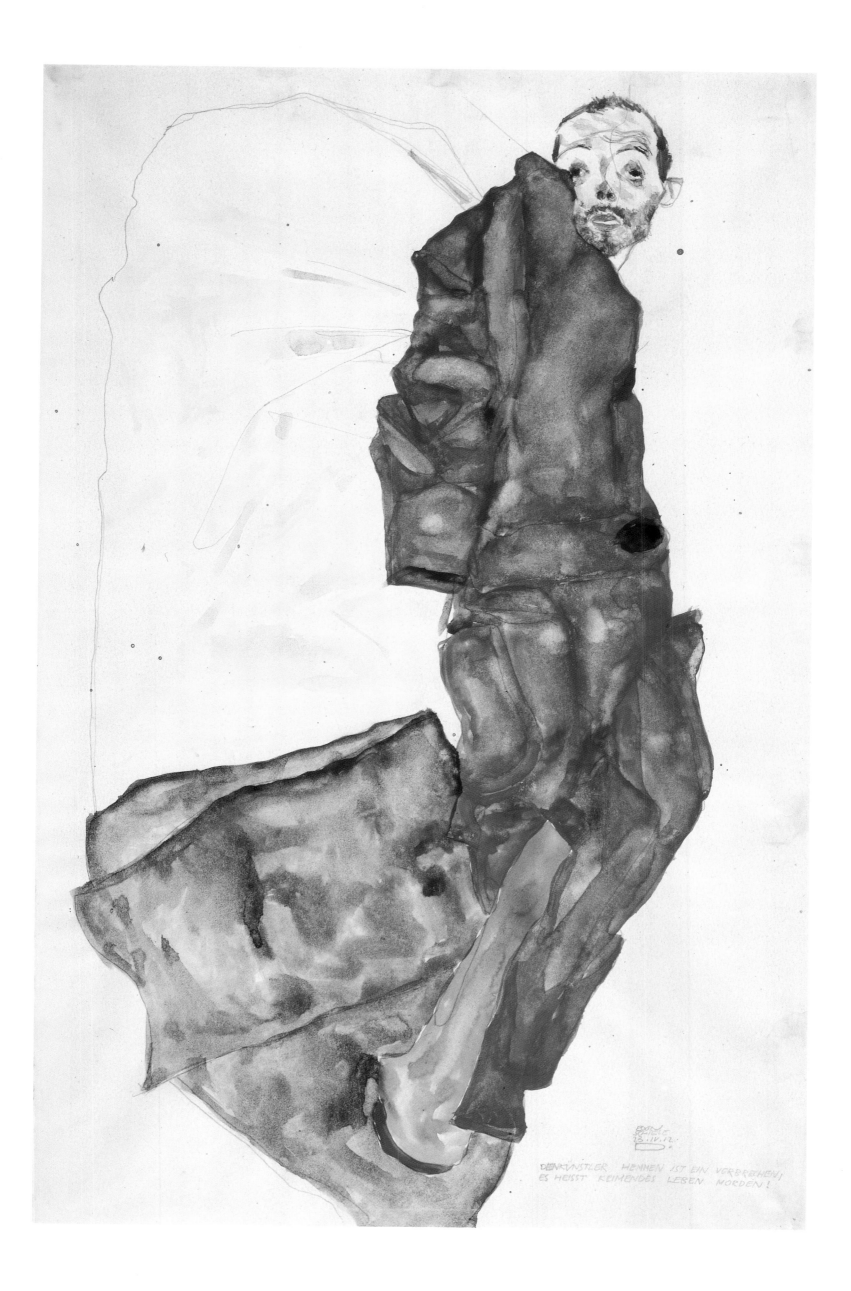

PLATE 9

Portrait of a Woman (Valerie Neuzil)

1912. Gouache and pencil on paper, 9³/₄ x 9³/₄" (24.8 x 24.8 cm).
Signed and dated, lower right. Kallir D. 1196

Despite his reputation as a libertine, Schiele actually had a fairly conventional sex life, consisting essentially of monogamous relationships with two women: Valerie (Wally) Neuzil (his principal model and lover from about 1911 through 1914) and Edith Harms (whom he married in 1915). If there was anything untoward about the relationship with Wally, it was not so much that the couple never wed (prostitution and extramarital sex were rampant in *fin-de-siècle* Vienna), but that Schiele made no attempt to conceal the affair and, indeed, openly cohabited with his paramour.

Little is known about Wally Neuzil. It appears she was what the writer Arthur Schnitzler famously termed a *süsses Mädel* (which translates, somewhat uncomfortably, as "sweet young thing"). That is to say, she was one of those basically naive, young, lower-class women who came to seek their fortunes in Vienna around the turn of the century and were quickly taken advantage of by older and more sophisticated men. Not quite prostitutes, these women nevertheless were not respectable enough ever to be considered as long-term mates. It is said that Wally at first modeled for Klimt, who then passed her along to his young protégé. She was seventeen in 1911, when Schiele first met her.

Wally's face is not immediately recognizable in Schiele's 1911 drawings and watercolors, possibly because he still had numerous other models at the time, or because she had not yet assumed a concrete identity for him. However, their relationship deepened when the couple moved to Krumau together in 1911, and Wally followed Schiele to Neulengbach later that year. (Though Wally often spent the night, Schiele insisted that she retain separate lodgings—probably not so much for the sake of propriety as to maintain a certain distance between them.) By 1912, Wally's distinctive features—her broad mouth, red hair, and large green eyes—turn up frequently in Schiele's work.

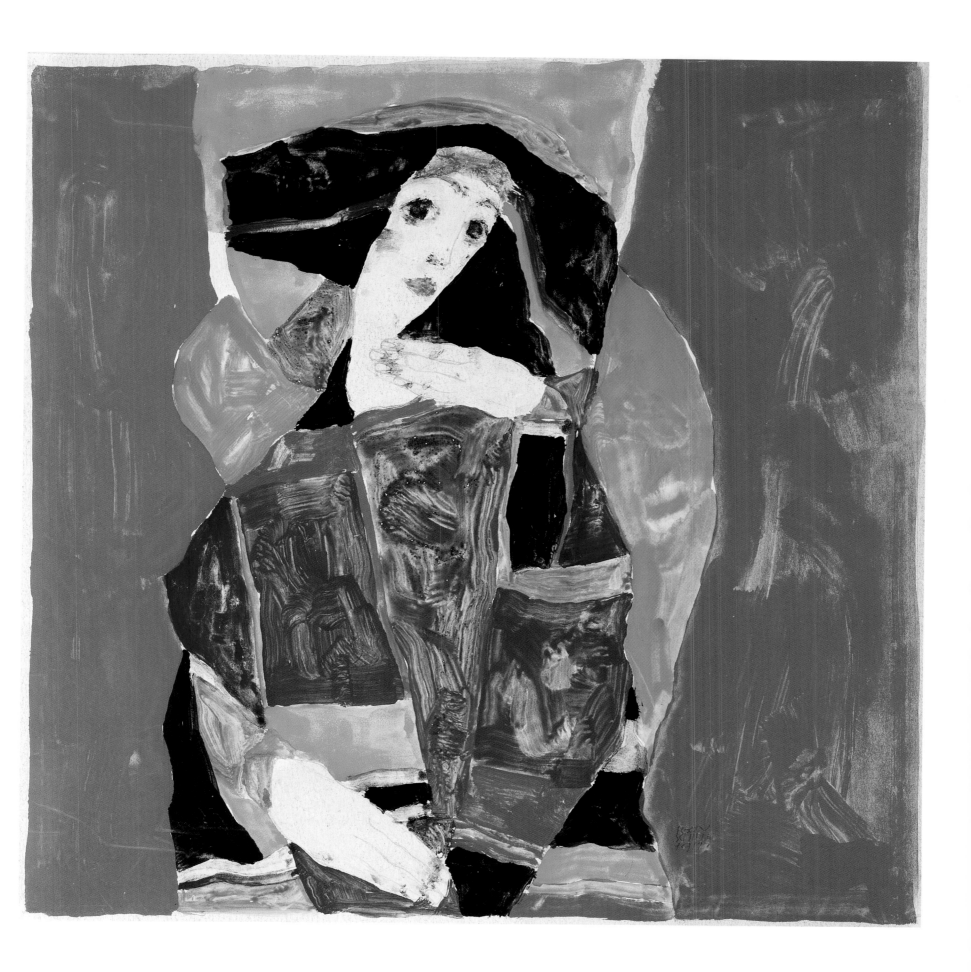

PLATE 10

Self-Portrait, Bust

1912. Watercolor and pencil on paper, 13³/₄ x 10" (35 x 25.3 cm).
Signed and dated, lower right. Kallir D. 1174. Promised gift to
the National Gallery of Art, Washington, D.C., in memory of Otto Kallir

Self-Portrait, Bust was probably done toward the end of 1912. The evident anger and pain in Schiele's eyes may be considered a natural response to the aftermath of his imprisonment earlier that year. In contrast to his prior self-portraits, the artist was not playacting here. Both defiant and confused, he was slowly beginning to comprehend that the demands of bourgeois society could be flouted only at grave personal risk. Over the course of the ensuing years, this realization would profoundly affect Schiele's view of his artistic mission.

This late 1912 self-portrait also exhibits certain subtle stylistic changes that become more pronounced in Schiele's subsequent work. His line is noticeably bolder than earlier in the year. He has switched to a softer, darker pencil and now uses drier, somewhat denser paint. These changes will gradually lead him back to more fully modeled, textured paint surfaces and a more representationally accurate drawing style.

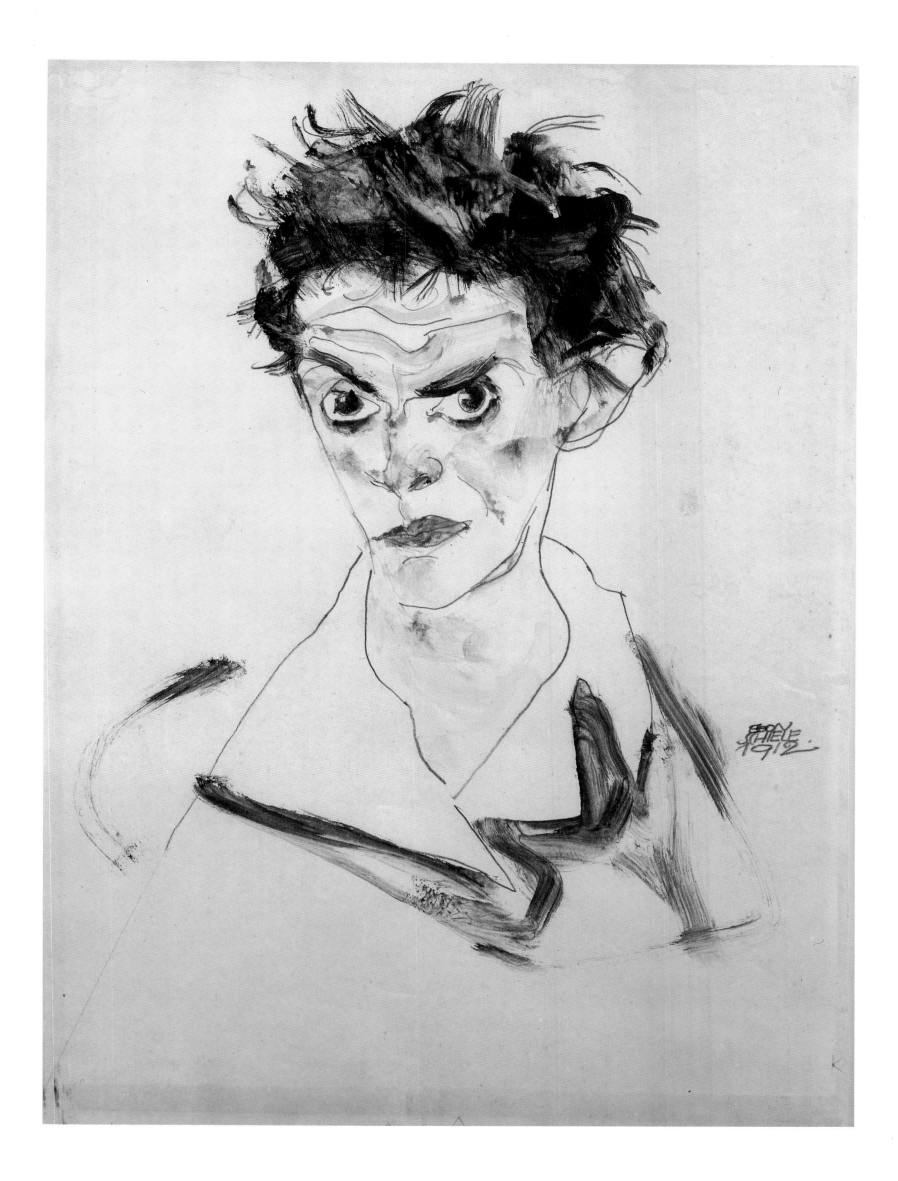

PLATE 11

Autumn Sun I (Sunrise)

1912. Oil on canvas, 31⁵/₈ x 31³/₄" (80.2 x 80.5 cm).
Signed and dated twice, center right. Kallir P. 236.
Private collection, courtesy Galerie St. Etienne, New York

Schiele is most often thought of in connection with the human figure—an impression that derives from the predominance of such subjects among his works on paper. However, if one looks to his oils (which the artist considered his most important work), landscape subjects account for fully a third of the mature output. From an early age, Schiele had sought solace in nature. Long walks were his way of escaping from what he termed his "lifeless schooling" and from a home life grown increasingly disturbed and tenuous. Schiele identified closely with nature, in which he saw correlatives for human emotional states. "Above all I observe the physical movements of mountains, water, trees, and flowers," he wrote. "Everywhere one is reminded of similar movements in human bodies, of similar manifestations of joy and suffering in plants."

In this spirit, Schiele in 1911 embarked on a series of anthropomorphic tree "portraits"—a project he pursued over the course of the next year and, with diminishing intensity, for the rest of his life. There is a close kinship between the febrile trees of 1911–12 and the figures in Schiele's contemporaneous allegories. Both represent humankind's isolation in a hostile environment. The trees are typically rooted in cold, barren earth and silhouetted against a blank, unconsoling sky. Weak and frail, they almost invariably require supporting stakes and seldom carry more than a few leaves. "One experiences an autumnal tree in summer most profoundly," Schiele explained. "This melancholy I want to paint." Winter and autumn were for him the death forces against which the little trees vainly but nobly struggled.

Compositionally, the tree portraits have an elemental structure that places them somewhere between Schiele's more complex townscapes and his pared-down figure drawings. The interlocking, essentially horizontal forms of sky and earth are worked in various patterns against the vertical trunks. The simple, organic rhythm of these compositions recalls the so-called Parallelism of the Swiss Symbolist Ferdinand Hodler, who was a great favorite of Schiele's. For Hodler, however, the parallel appearance of natural forms, such as trees in a forest, was indicative of a divine order and harmony, whereas Schiele saw in these same forms an intrinsic lonesomeness that may have evidenced God's desertion.

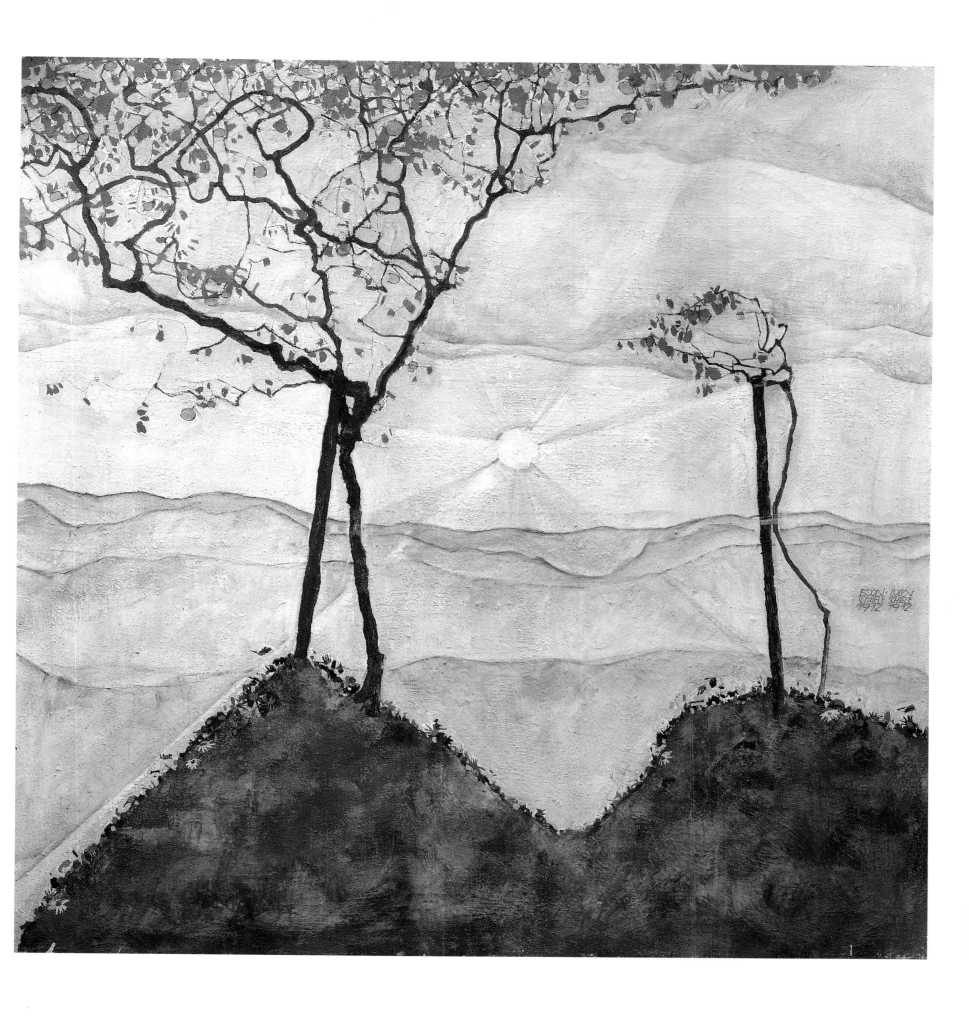

PLATE 12

Agony

1912. Oil on canvas, 27¹/₂ x 31¹/₂" (70 x 80 cm). Signed and dated,
upper right. Kallir P. 230. Bayerische Staatsgemäldesammlungen,
Neue Pinakothek, Munich; Inv. 13073

Schiele believed that artists are like priests or monks: spiritually enlightened beings whose mission it is to share their special vision with the more ignorant masses. This notion dates back at least to the German Romantics of the early nineteenth century. For Schiele, the concept was concretely embodied by the magisterial Gustav Klimt, whose floor-length painting caftan and balding pate gave him the appearance of a genuine religious sage. Schiele fairly early on got himself a similar robe, so as better to enact the role of disciple.

The relationship between Klimt and Schiele has often been overdramatized by the latter's biographers, and in truth it is difficult to ascertain just how close the two artists were. Did Klimt—who was extremely generous toward all younger colleagues—really show Schiele any more encouragement than he did others? And did Schiele, regardless of Klimt's attentions, truly idolize him as a sort of artistic surrogate father? Klimt's influence, especially on Schiele's early work, is evident, but Schiele also made a point of rejecting the more decorative aspects of Klimt's style.

In any event, many of Schiele's paintings from the years 1911 through 1913 depict spiritual interchanges between a godlike entity and an acolyte. Schiele characteristically put his own image into these works, usually in the position of the acolyte but sometimes in both roles. Klimt's physical resemblance to a monk has caused some observers to identify him as the senior figure in certain of these pictures, and it is generally agreed that he plays this part in the 1912 canvas *The Hermits* (fig. 15). *Agony* appears to be a more generalized interpretation of a similar subject. Neither figure has features that can conclusively be identified with a specific person. Carrying forward the religious metaphor, Schiele believed that artists, like saints, must suffer for their beliefs. *Agony,* which may well have been painted shortly after he was released from prison, is a telling testament to such travails.

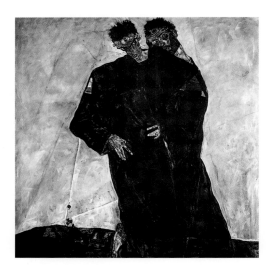

Fig. 15. **The Hermits.** 1912. Oil on canvas, 71¹/₄ x 71¹/₄"
(181 x 181 cm). Signed and dated three times, lower left.
Kallir P. 229. Leopold Museum–Private Foundation, Vienna

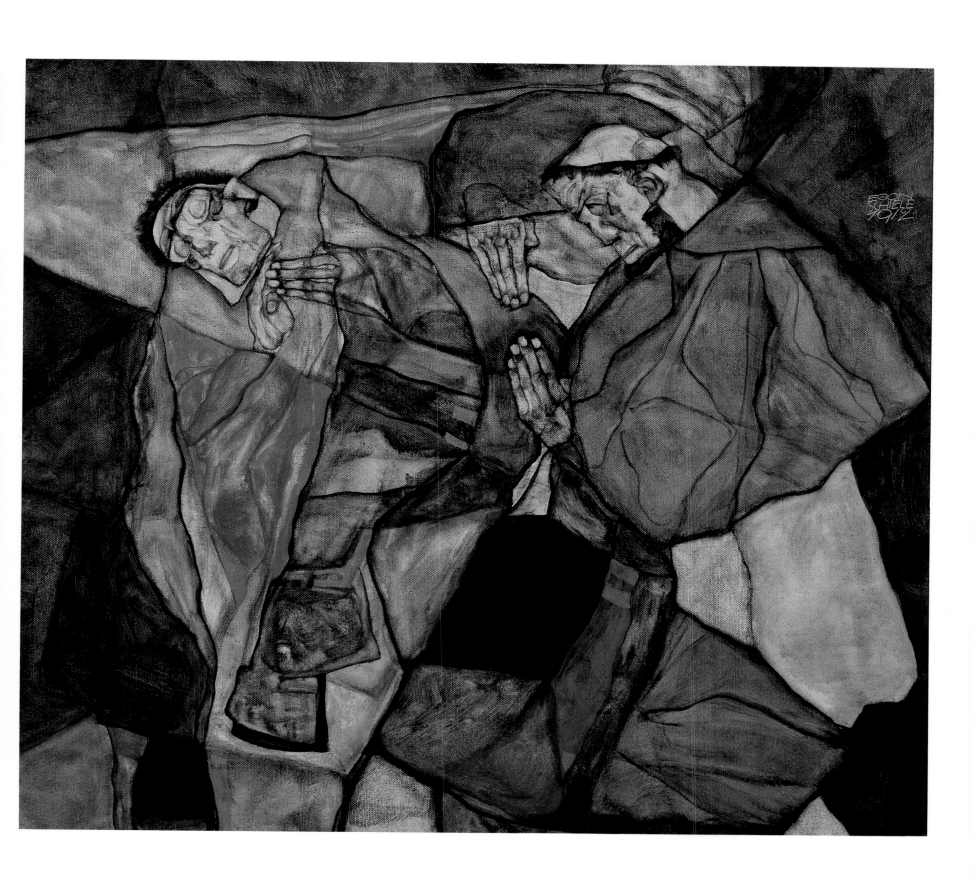

PLATE 13

The Bridge

1913. Oil on canvas, 35³/₈ x 35³/₈" (90 x 90 cm).
Signed and dated, lower left. Kallir P. 262.
Private collection, courtesy Galerie St. Etienne, New York

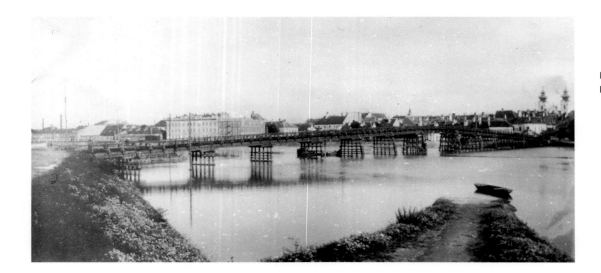

Fig. 16. Bridge in Györ, Hungary. c. 1920.
Photograph. Courtesy Galerie St. Etienne, New York

Toward the end of 1912, Gustav Klimt introduced Schiele to the industrialist August Lederer and his wife, Serena. The Lederers were among Klimt's most important patrons, but they were initially less than enthusiastic about Schiele's far more abrasive Expressionist work. Nevertheless, their adolescent son Erich, a budding collector, rapidly developed what became a lifelong fascination with Schiele and his art. The slightly older artist seemed to him a romantic, bohemian figure, whose sexual exploits (such as Erich imagined them to be) held particular appeal. As an adult, Erich Lederer formed one of the world's foremost collections of Schiele drawings and watercolors.

In 1912, the fifteen-year-old Lederer determined to use the proceeds of a winning lottery ticket to commission a portrait (fig. 6), and Schiele arrived at the family estate in Györ, Hungary, shortly before Christmas to begin work. August Lederer put at his disposal one room of his enormous liquor factory to use as a studio, and Schiele, treated as an honored guest, was allowed to share in the family's holiday celebrations. After a brief trip back to Vienna for New Year's, the artist returned to Györ in January 1913 to complete the commission. Exploring Györ in his spare time, he came upon the subject of *The Bridge* (fig. 16). Schiele was delighted with the structure's unusual architecture, which he called "quite Asiatic, Chinese-like." The painting was begun in the early weeks of 1913 and finished by winter's end. Like other paintings done at this time, when Schiele was especially low on funds, *The Bridge* was executed on two pieced-together lengths of canvas.

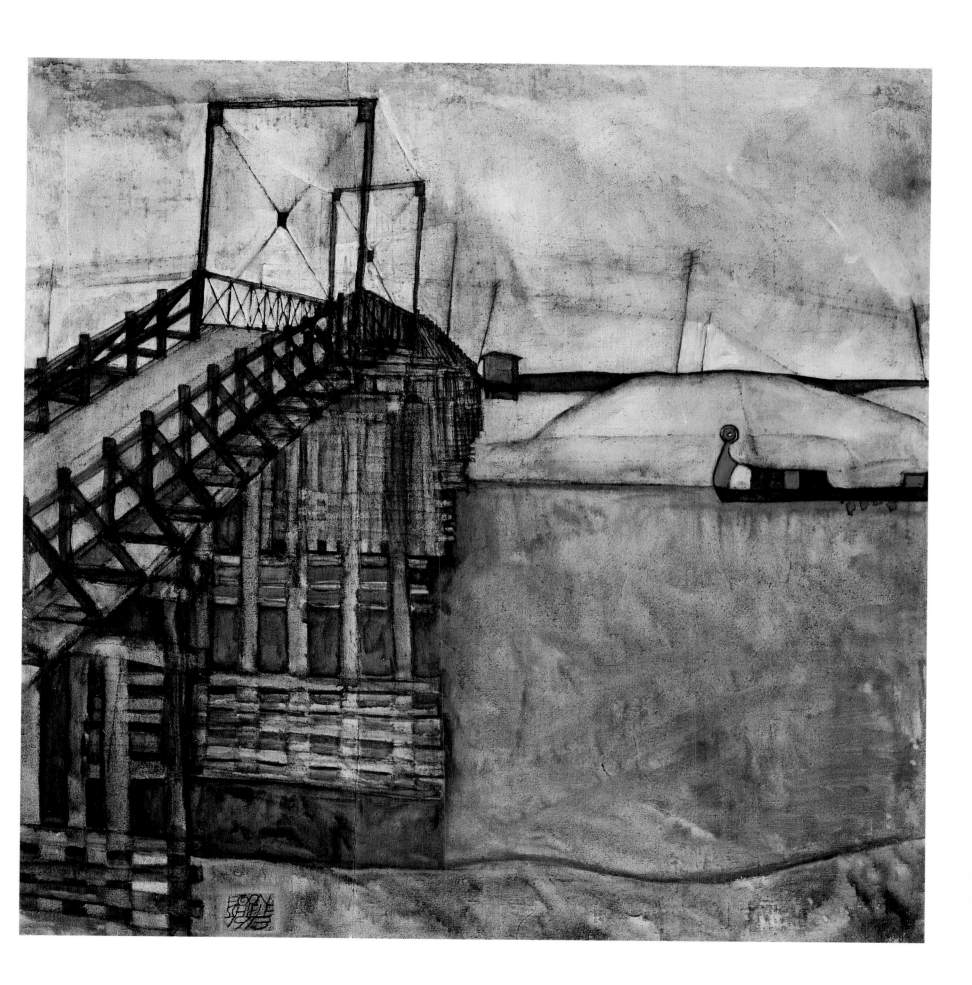

PLATE 14

Holy Family

1913. Gouache and pencil on parchmentlike paper,
18¹/₂ x 14³/₈" (47 x 36.5 cm). Signed and dated,
lower right. Kallir P. 248. Private collection

Schiele's allegorical cosmology, though baffling to some present-day observers, actually revolves around a

few relatively simple concepts: the exchange of enlightenment between a mentor and a disciple (or a father-

son pairing), the equation of procreation with artistic creation, and the conviction that art is ultimately the

only defense against mortality. One indication of the importance which Wally Neuzil assumed in Schiele's

life is the manner in which the artist's relationship with his model/lover altered his allegorical formulations.

The painting *Cardinal and Nun* (fig. 17) is generally read as a sacrilegious blast at conventional

morality, probably executed in the aftermath of the artist's 1912 imprisonment. If the subjects were indeed

a generic cardinal and nun in carnal embrace, that interpretation would perhaps be accurate, but the iden-

tification of Egon and Wally in the title roles turns the canvas into a more personal statement that assumes

specific significance within the context of Schiele's allegorical schema. If Schiele was a priest of art, Neuzil

was his natural helpmeet—his nun, as it were.

The theme is carried forward in the 1913 gouache *Holy Family*. Once again, this is not a generic

depiction of the subject, but a specific one, with Egon and Wally as the principal characters. No one has ever

thought to characterize *Holy Family* as a sacrilegious work, though the Catholic Church (to which Schiele

nominally belonged) certainly would not have sanctioned Schiele's portrayal of himself and his lover as

Joseph and Mary. Yet Schiele truly believed that his union with his model was holy, and that its offspring—

art—was humankind's salvation.

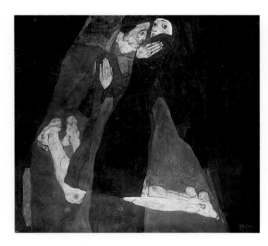

Fig. 17. **Cardinal and Nun.** 1912. Oil on canvas, 27¹/₂ x 31¹/₂"
(69.8 x 80.1 cm). Signed and dated, lower right. Kallir P. 232.
Leopold Museum–Private Foundation, Vienna

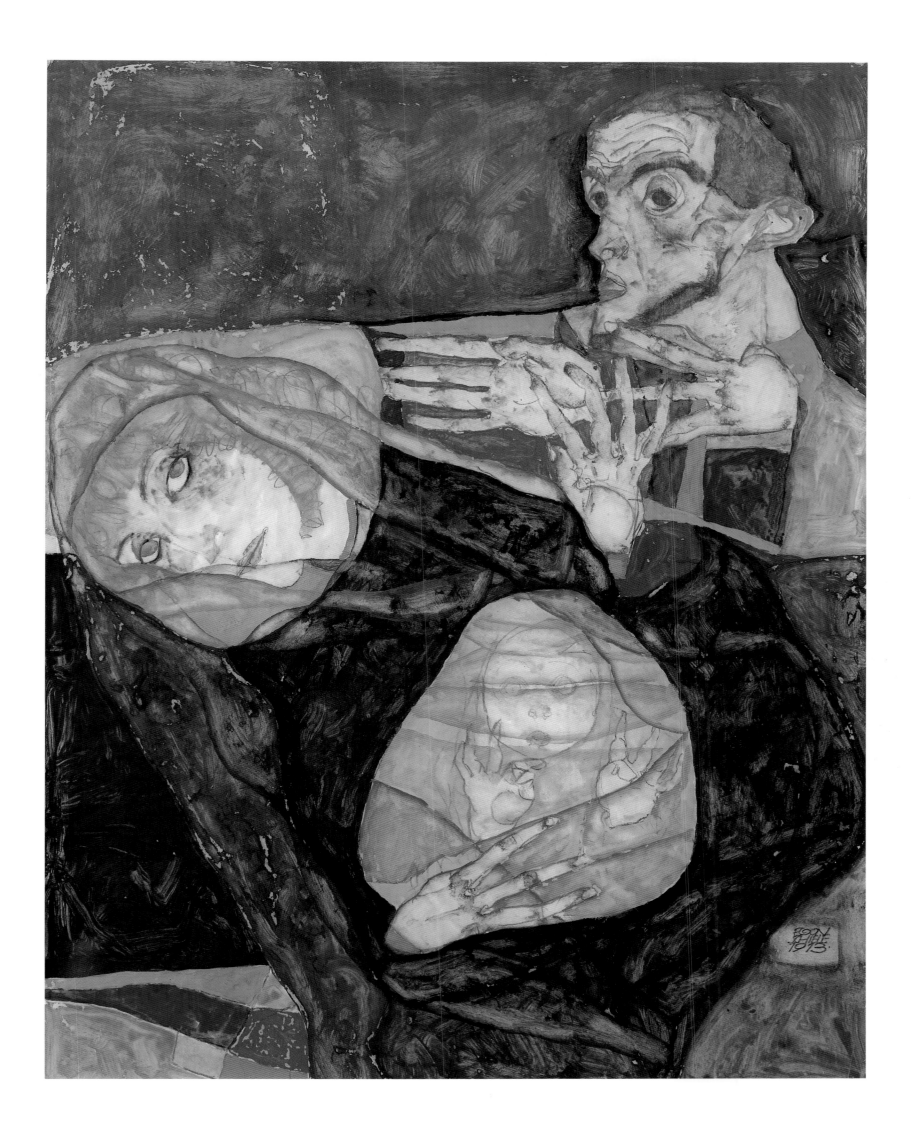

PLATE 15

The Truth Unveiled

1913. Gouache, watercolor, and pencil on paper,
19 x 12⅝" (48.3 x 32.1 cm). Signed and dated, lower left.
Inscribed "Die Wahrheit wurde enthüllt," lower left. (Verso Kallir D. 1320.)
Kallir D. 1443. Private collection

Many of Schiele's 1913 and 1914 self-portraits and nudes—the former usually dressed in short tunics—were related to two large allegorical canvases, *Conversion* (Kallir P. XLII) and *Encounter* (fig 18). Since neither painting was ever completed and both are now lost or destroyed, one can only speculate as to the intended appearance of each. However, surviving fragments and photographs suggest that these compositions involved friezelike chains of human figures: a seer with his disciples. The tunics were intended to provide pictorial unity and to signify membership in a hieratic brotherhood.

The *Truth Unveiled* may have been a direct study for one or both of the two lost paintings, or simply an expression of ancillary pictorial and philosophical concerns. It is hard to know how much importance to assign the inscribed title. As a rule, Schiele did not title his works on paper, but this particular watercolor—one of several similar examples dating from 1913—is an exception. Schiele's friend the collector Erich Lederer recalled that these uncharacteristic inscriptions were added as afterthoughts and had relatively little significance. Many of these drawings were exhibited at the Munich Secession in late 1913 and early 1914, suggesting that Schiele used the inscriptions either to group all his contributions cohesively, or, more practically, to help identify and retrieve them after the showing (a perennial problem).

Over the course of 1913, Schiele became increasingly concerned with volume, and *The Truth Unveiled* is typical of the manner in which his brush now systematically began to mold human flesh. The drapery was still largely defined by the two-dimensional contours of the surrounding drawing and the gyrations of the paint, but the particolored dabs on the skin searched out crevices and curves with new vigor. The bright, unnatural reds, blues, and greens suggest the influence of Fauvism or German Expressionism—an influence which is, however, not detectable in the generally subdued palette of Schiele's contemporaneous oils. Use of denser gouache in place of watercolor heralded an incipient interest in painterly effect, which would grow stronger throughout the remainder of Schiele's career.

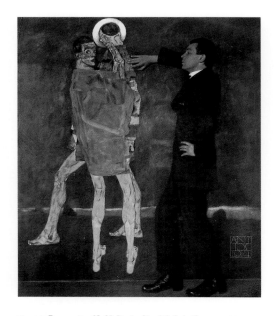

Fig. 18. **Encounter (Self-Portrait with Saint).** 1913. Oil on canvas, 78⅜ x 78⅜" (199 x 199 cm). Kallir P. 259. Present whereabouts unknown. This photo, in which Schiele poses in front of the partially completed canvas, is the only surviving visual record of this piece

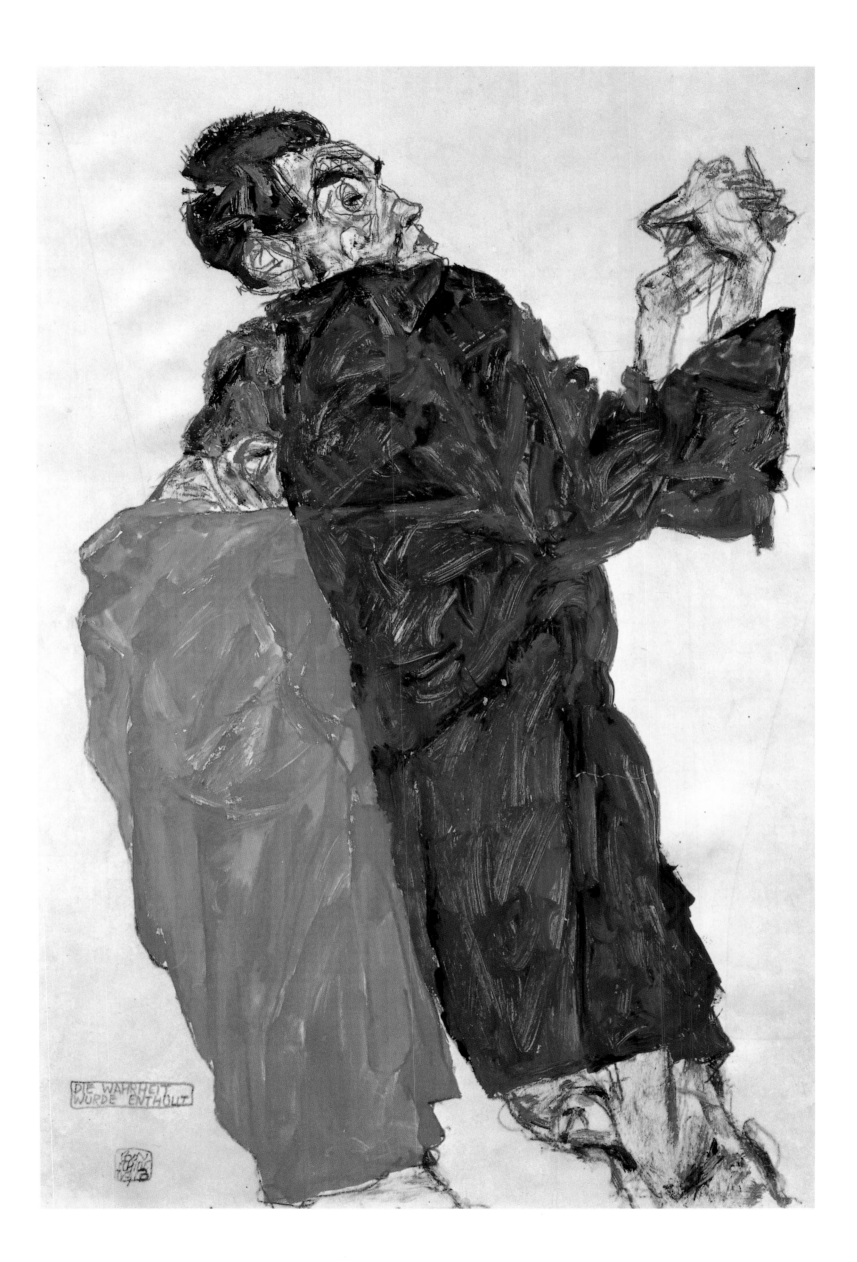

PLATE 16

Reclining Female Nude on Red Drape

1914. Gouache and black crayon on paper, 12¼ x 18⅞" (31.2 x 48 cm).
Signed and dated, lower left. Kallir D. 1498. Private collection

By 1914, Schiele had reached the midpoint of his mature career. His approach to his subjects was becoming less subjective and his style more noticeably realistic, but neither development was as yet fully realized (see also front cover).

In *Reclining Female Nude on Red Drape*, delicately modeled flesh is played off against the more two-dimensional drapery and stockings. With the lightest touch of watercolor, Schiele traced the outlines of his figure, suggesting a bulk and volume that are further augmented by the voluptuous contours themselves. The model is something more than a sex object, and something less than a full-fledged person. Clearly her body is on display, nestled among the soft folds of the drapery like a brooch in a jeweler's case. Yet the greater realism of Schiele's evolving style has given the model a semblance of autonomy: Schiele controls her body, but not her soul.

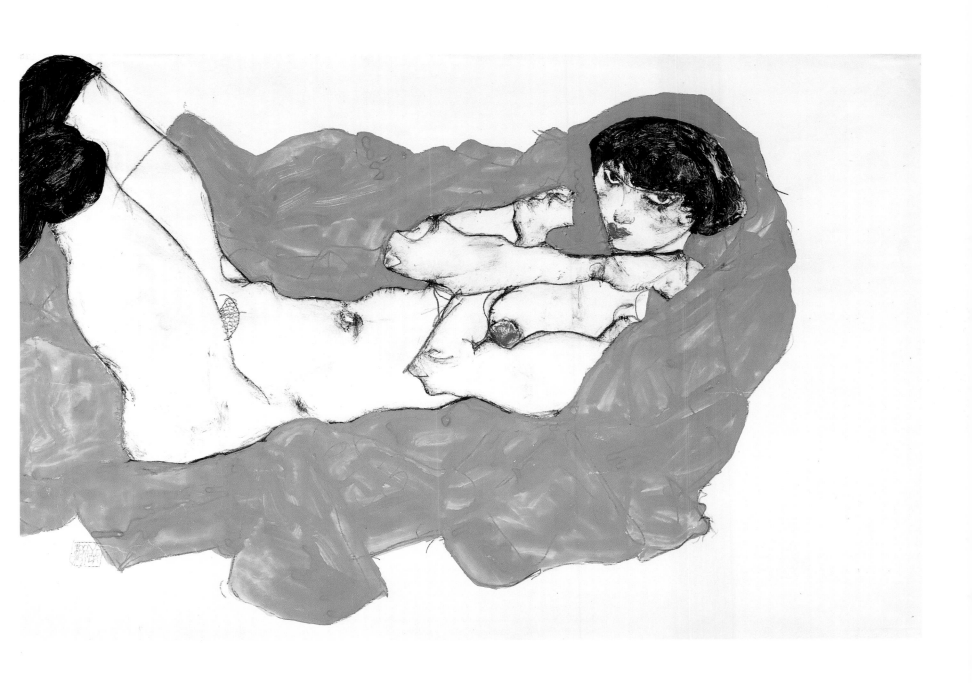

PLATE 17

Woman Undressing

1914. Gouache and pencil on paper, 18¹/₂ x 12³/₄" (47 x 32.4 cm).
Signed and dated, lower right. Numbered "92" by another hand,
lower right. Kallir D. 1554. Private collection

Fig. 19. **Squatting Woman.** 1914. Drypoint etching,
19 x 12⁵/₈" (48.3 x 32.2 cm). Kallir G. 6

Though conditioned by an overriding thrust toward greater verisimilitude, some of Schiele's experimental techniques of 1914 appear superficially radical. This is certainly true of the wild hatching that emerged around midyear. Drawings from this period recall the pseudoprimitivism of some of Oskar Kokoschka's early work. However, Schiele's seemingly erratic lines (unlike Kokoschka's) were actually busy defining three-dimensional volumes.

The bizarre seams and scars that punctuated Schiele's figure drawings in 1914 may have derived from his contemporaneous experiments with drypoint etching (see fig. 19). Since Schiele (who had little patience with printmaking and gave it up after a few months) never learned the more complex techniques for transferring shadow and tone to the plate, he had to make do with line alone. Hatching is the tried-and-true way for embellishing an etched line and modeling richer forms. One cannot altogether know whether this approach—evident in Schiele's etchings—influenced his drawings, or vice versa.

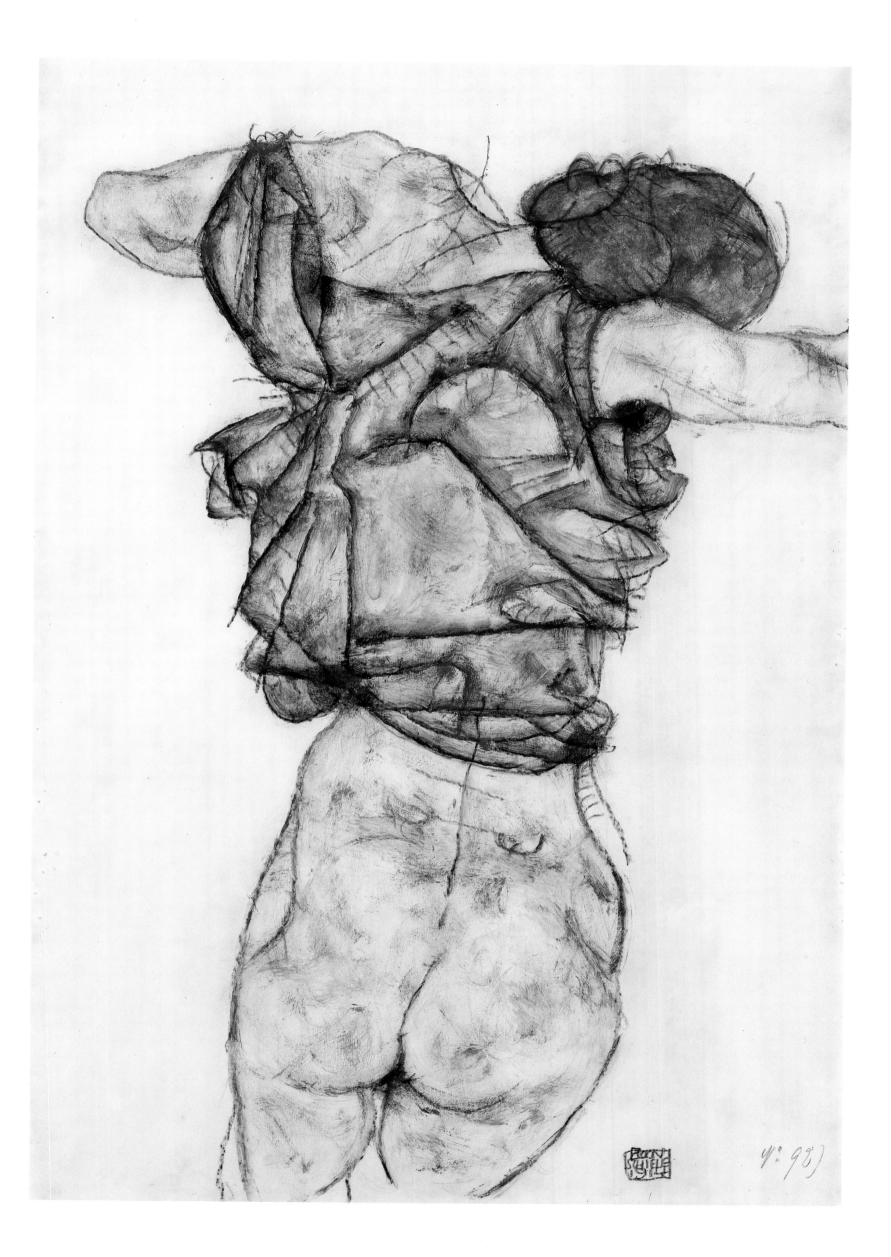

PLATE 18

Two Girls, Lying Entwined

1915. Gouache and pencil on paper, 12⁷/₈ x 19⁵/₈" (32.8 x 49.7 cm).
Signed and dated, lower center. Kallir D. 1743.
Graphische Sammlung Albertina, Vienna; Inv. 31.173

A corollary to Schiele's lifelong obsession with artistic vision was an interest in blindness as an allegorical concept. If the artist is a quasi-religious "seer," it stands to reason that blindness would be his nemesis. Blindness was first and foremost an accusation which Schiele hurled at a philistine public. The mother who failed to nurture her offspring was blind, as were Schiele's hypothetical disciples, whom he tried to lead to the light. But increasingly between 1913 and 1915, Schiele depicted himself with vacant, obscure, or blinded eyes: a humble aspirant rather than a true seer (fig. 20). As the artist attempted to emerge from the solipsism of adolescence, blindness became a metaphor for a lingering inability to establish meaningful contact with others.

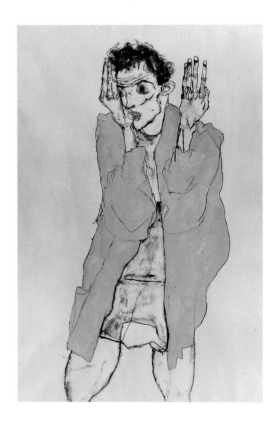

Fig. 20. **Self-Portrait with Raised Arms.** 1914. Gouache and pencil on paper, 19 x 12⁵/₈" (48.4 x 32.2 cm). Kallir D. 1648. Collection Hans Dichand

It is significant that Schiele at this time was struggling toward more mature sexual relationships. Distancing himself from Wally Neuzil (who, as his model and illicit lover, was by the standards of the day scarcely better than a prostitute), he was preparing to marry a bourgeois "good girl," Edith Harms. In the process, he was succumbing ineluctably to the prevalent double standard: Women were sex objects or people, but not both. Yet while Schiele on one level accepted this stereotype, he did not immediately embrace it. Especially during this period, his portrayals of women are extremely ambiguous.

Depicted singly, the button-eyed or eyeless female nudes drawn by Schiele during 1914 and 1915 suggest an effort to depersonalize female sexuality. Yet, like the blind self-portraits, these doll-like figures may symbolize a failed struggle to make human contact. A third reading is suggested by *Two Girls, Lying Entwined*. Here it is the clothed model who appears as the limp and lifeless rag doll, while the nude is fully fleshed out, vibrantly alive. What then did Schiele really want? If the bold, sensual Wally was more "real" than the chaste, genteel Edith, was he about to make a big mistake?

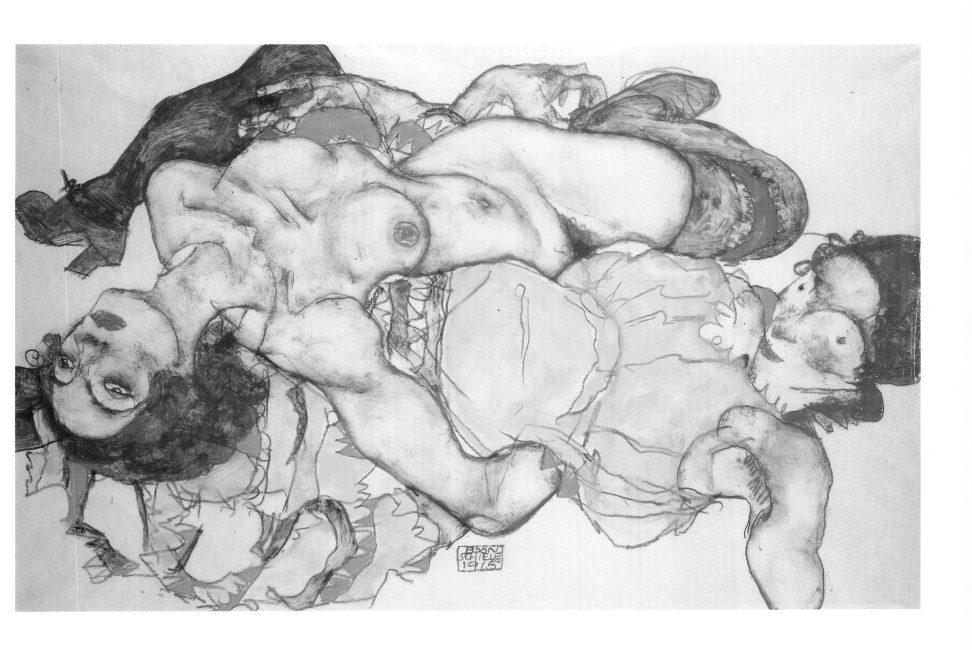

PLATE 19

Death and Maiden

1915. Oil on canvas, 59 x 70⅞" (150 x 180 cm).
Signed and dated, upper right. Kallir P. 289.
Österreichische Galerie, Vienna; Inv. 3171

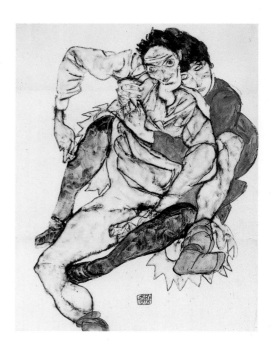

Fig. 21. Seated Couple (Egon and Edith Schiele).
1915. Gouache and pencil on paper, 20⅝ x 16¼"
(52.5 x 41.2 cm). Signed and dated, lower center. Kallir
D. 1788. Graphische Sammlung Albertina, Vienna; Inv. 29.766

It is not coincidental that as Schiele approached marriage in 1914–15, heterosexual couples began to appear as representations of concrete relationships rather than (as previously, see fig. 17) metaphors for artistic creation. *Death and Maiden* is readily interpreted as a farewell portrait of Egon with his lover Wally Neuzil. The pair cling, more in desperation born of habit than out of true love. The drapery "cocoon" which envelops the central figures offers scant protection from the barren surrounding environment.

Yet was the alternative truly better? The gouache *Seated Couple* (fig. 21), done in the first months of Schiele's marriage to Edith Harms, suggests not. This is perhaps the most poignant of all Schiele's "blind" self-portraits. The subjects are very obviously not allegorical figures, but Egon and his bride. For all the stylization of her features, Edith is a real person, with living, seeing eyes, whereas Egon lies limp and lifeless in her arms. Her embrace is one of unrequited passion, his pose that of numbed indifference or incomprehension. Significantly, Edith is fully clothed, while Egon is naked from the waist down. Is he perhaps masturbating? There is, in any case, no sexual intimacy between the two, and no tenderness beyond Edith's clinging embrace. Even in marriage, Schiele remained sexually and personally alienated.

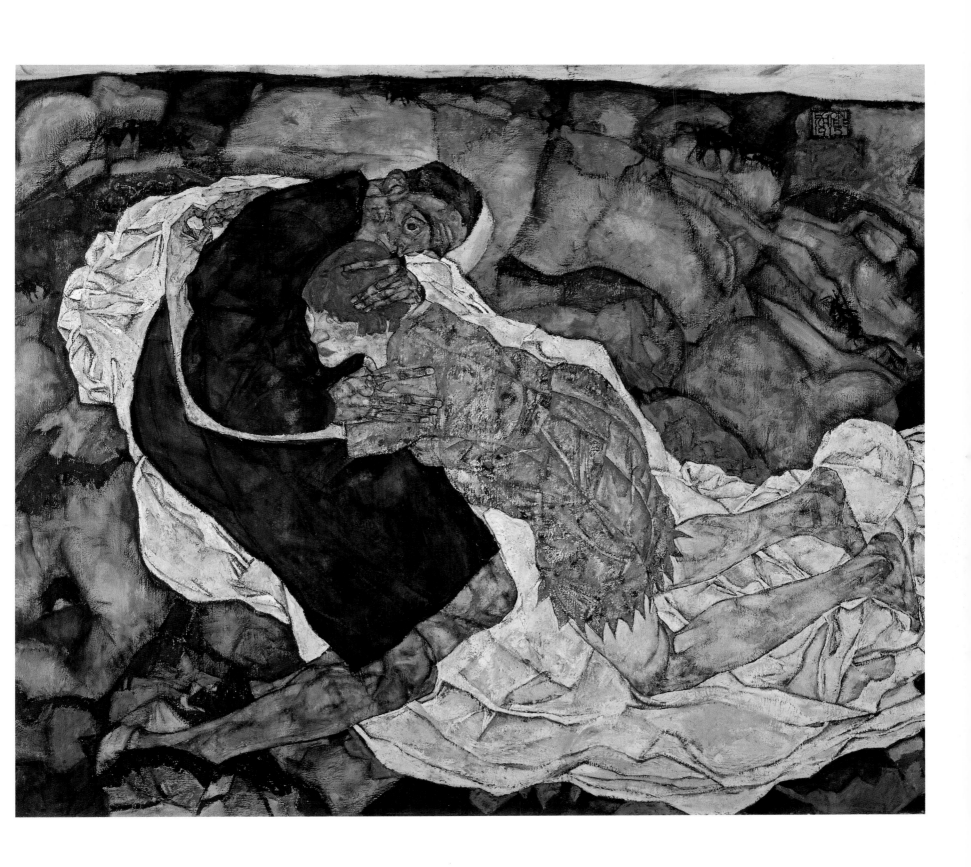

PLATE 20

Portrait of the Artist's Wife, Standing
(Edith Schiele in Striped Dress)

1915. Oil on canvas, 70⁷/₈ x 43¹/₄" (180 x 110 cm). Signed and dated, lower right.
(Verso: Kallir P. 274.) Kallir P. 290. Gemeentemuseum voor Moderne Kunst,
The Hague; Inv. 18–1928

The early weeks of Schiele's marriage were troubled. As he was just beginning his military service, he had very little contact with his bride, Edith, who whiled away the hours alternately pining for Egon and flirting with another soldier. This relatively innocent infidelity enraged the artist, who believed that the supposedly pure young woman whom he had married was in reality less loyal than Wally, his former illicit lover. It was a strange conundrum, for if Edith was not as virtuous in her outward behavior as Egon might have wanted, neither was she fully responsive in their private sexual encounters.

When Schiele painted *Portrait of the Artist's Wife,* in August 1915, the relationship had grown more harmonious. Nonetheless, the painting can hardly be considered a reflection of marital bliss. Edith is depicted as an inanimate creature not unlike the blind "dolls" found in Schiele's contemporaneous drawings (see plate 18). Klimt's society portraits were similarly vacuous, but in his case the intended effect was flattery: dumb beauty enshrined. Edith's striped dress—more alive than her vacant, sweet face—is a virtual parody of the elder artist's florid costumes and richly ornamented settings. The background void was Schiele's customary way of inverting Klimt's decorative formula. Edith not only stands in the void, she embodies it, in the process exposing the hollowness of Klimt's portraits and of the stereotype they represented. Was Schiele here satirizing the bourgeois creature who had replaced his more sexually sophisticated lover? Was he deliberately creating an idealized virgin as a rebuke to his wife's perceived betrayal? Or did he in his heart want to believe that this pretty dolly was the real Edith?

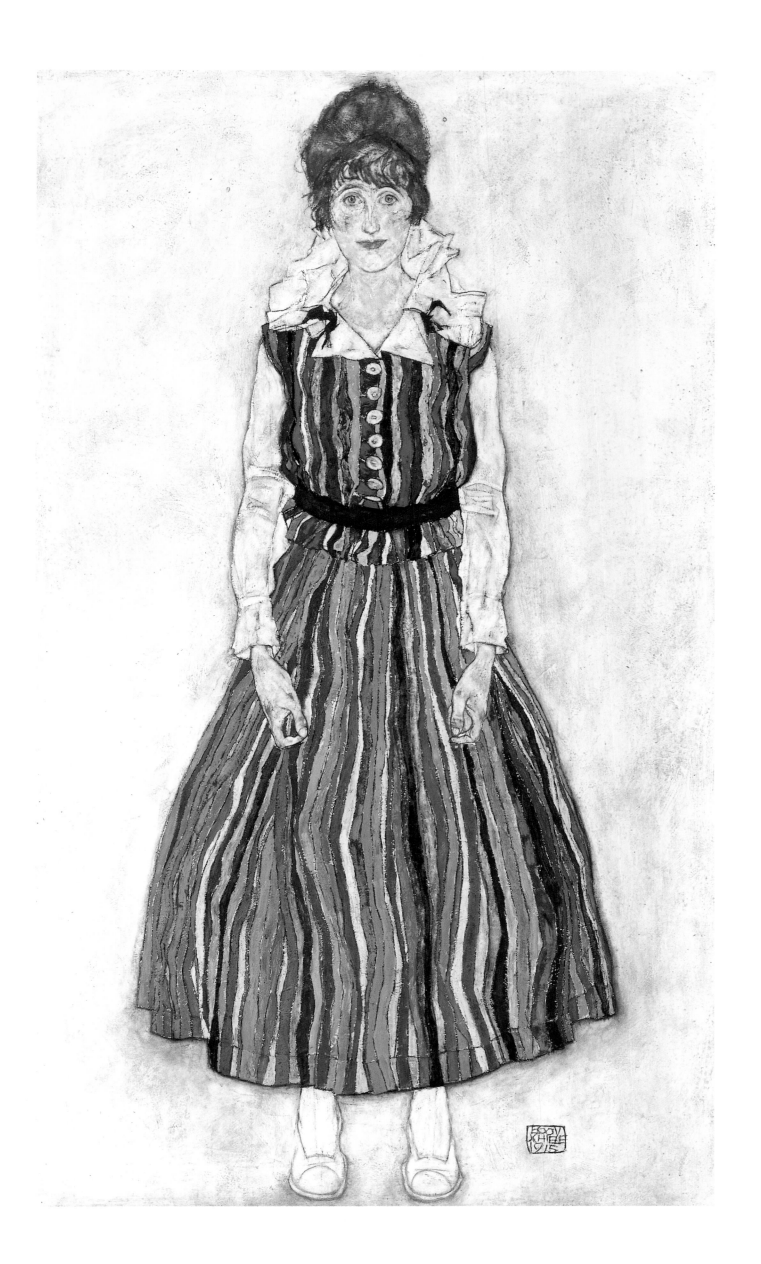

PLATE 21

Little Girl with Blond Hair in Red Dress

1916. Gouache and pencil on paper, 18$^1/_8$ x 12$^1/_8$" (46 x 30.8 cm).
Signed and dated, lower right. Arnot collector's stamp and export stamp, verso.
Kallir D. 1818. Private collection, courtesy Galerie St. Etienne, New York

After being sent to prison in 1912 for "offenses against public morality" (a charge that was triggered by the artist's use of underage models), Schiele almost completely stopped drawing children. The few such works that appear in his oeuvre between 1912 and 1918 (when he employed a mother-and-child modeling team) are with rare exceptions commissioned portraits or studies of family and friends. As such, most of the sitters can be readily identified, but the *Little Girl with Blond Hair in Red Dress* is an anomaly. Her name is thus far unknown, and only a single gouache has ever been documented. Possibly she was the child of a villager in the rural hamlet of Mühling, where Schiele, a soldier in the Austro-Hungarian army, and his wife were stationed in 1916. In any event, the girl's pensive gaze and lightly veiled unhappiness eloquently testify to Schiele's respect for the integrity of his model's feelings and his steadfast refusal to romanticize childhood.

PLATE 22

Mother with Two Children III

1917. Oil on canvas, 59 x 62½" (150 x 158.7 cm). Signed and dated,
lower center. Kallir P. 303. Österreichische Galerie, Vienna; Inv. 4473

Schiele's feelings about motherhood were exceedingly complex. He had a poor relationship with his own mother, who tended to whine about his failure to fulfill his filial obligations rather than support him in his artistic pursuits. From Schiele's point of view, his mother—for that matter, any mother—was little more than a useful expedient, a means to an end. It was the child who represented life and the creative spirit, as the artist confirmed in his 1911 painting *The Birth of Genius* (fig. 22). Typically, Schiele in this painting took a traditional subject from German art (one thinks of Max Klinger's well-known etching *The Dead Mother*) and endowed it with intensely personal significance.

Begun and substantially completed in 1915, *Mother with Two Children III* represents a minor metamorphosis in Schiele's attitude toward motherhood. At least this woman, unlike many of his earlier depictions of mothers, is not dead. The artist's relationship to his family was improving, and he was inclined to view his mother (who posed for the present painting) more charitably. Furthermore, an infant nephew had now entered his life: The son of his sister Gerti and his best friend Anton Peschka was born toward the end of 1914. Little Anton Jr. served as the model for both babies in *Mother with Two Children III*. Nonetheless, the painting can hardly be considered a family portrait. Though Schiele's orientation was conditioned by personal circumstances, his allegories were never explicitly autobiographical.

At first glance, the threesome depicted in *Mother with Two Children III* seems to constitute a break from the duos who inhabit most of Schiele's allegories. However, it is still the two infants who carry the weight of the picture's message. They are, after all, a prototypical Schiele pairing, representing two antithetical and yet complementary responses to life: the one on the left passive, asleep, sightless; the other active, awake, a "seer." The mother, by comparison, fades into the background. She may not be dead, but she is exhausted. Having already performed her most important function, she survives only to nurture passively the life she has created.

Fig. 22. **The Birth of Genius (Dead Mother II).** 1911. Oil on wood, 12⅝ x 10" (32.1 x 25.4 cm). Initialed and dated, lower left. Kallir P. 195. Presumed destroyed

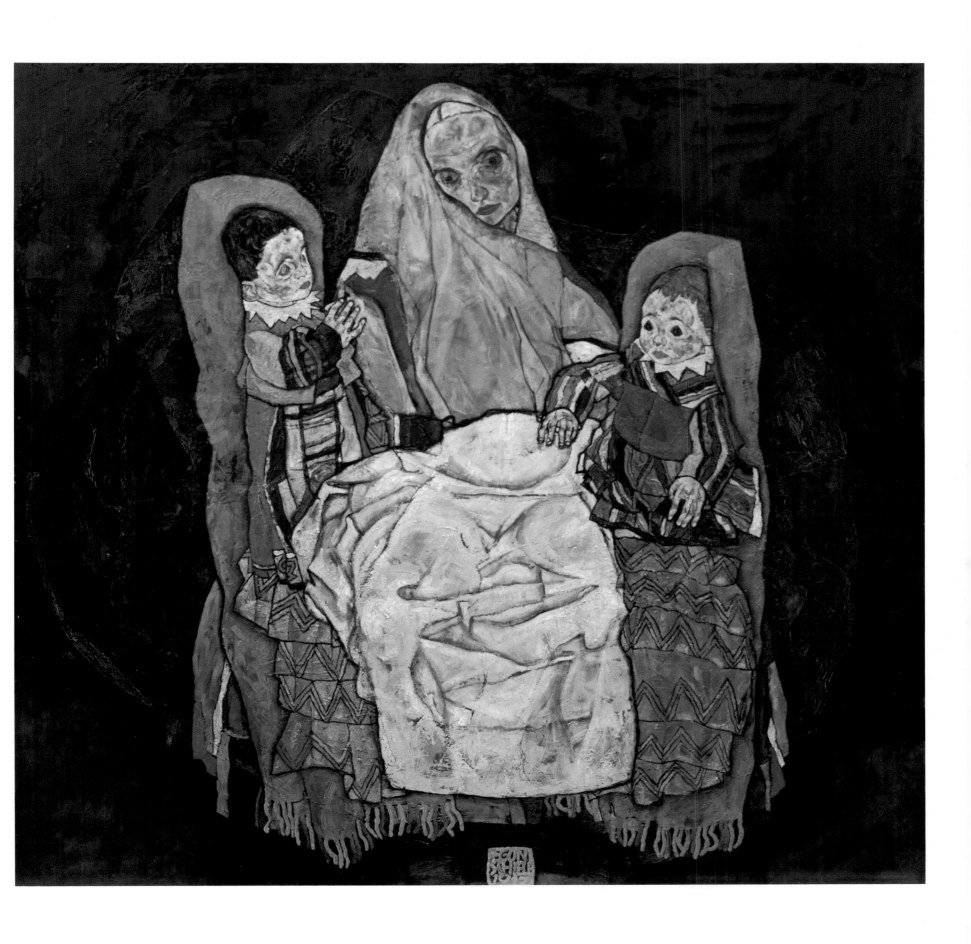

PLATE 23

Reclining Woman with Green Stockings

1917. Gouache and black crayon on paper, 11⁵/₈ x 18¹/₈" (29.4 x 46 cm).
Signed and dated, lower right. Arnot collector's stamp and export stamp, verso.
Kallir D. 1995. Private collection, courtesy Galerie St. Etienne, New York

From about 1914 on, Schiele evolved a more representationally accurate style of rendering. In the process, his depictions of the female figure became more conventionally beautiful but lost something of their frenzied intensity. The artist's lines, formerly jagged and searching, became smooth and sure, capturing the curves of the body with unswerving accuracy. The complicated retracing, hatching, and scrolled embellishments seen in his earlier work were replaced by single, perfect strokes. Color always followed line. Schiele habitually began with a base glaze of ocher or brown, which defined the principal volumes. Over this he superimposed brief dabs of brighter gouache, mapping out salient bulges and concavities and describing key protuberances such as knuckles or cheekbones. The relatively three-dimensional approach which he used for flesh and drapery contrasted with the bolder stylization of hair and stockings. In the latter areas, the dense paint surface was essentially shaped by the flow of Schiele's brush.

Growing professional success in the last two years of his life enabled Schiele to emulate his mentor, Gustav Klimt, by employing a virtual harem of paid models. Edith, the artist's wife, became increasingly reluctant to pose, and it is said that (especially in 1918, when she was pregnant) Schiele found her figure too heavy for his tastes. Edith's sister, Adele, to the contrary, seems to have been a willing and desired model, and she may well have posed for *Reclining Woman with Green Stockings*. Like Klimt, Schiele saw the female figure as raw material necessary to the construction of his allegories. And like Klimt, he executed sheets and sheets of studies in order to generate pictorial ideas and compositions. The results, as well as Schiele's overriding goals, are visible in his later allegorical canvases, virtually all of which include female nudes (see fig. 10).

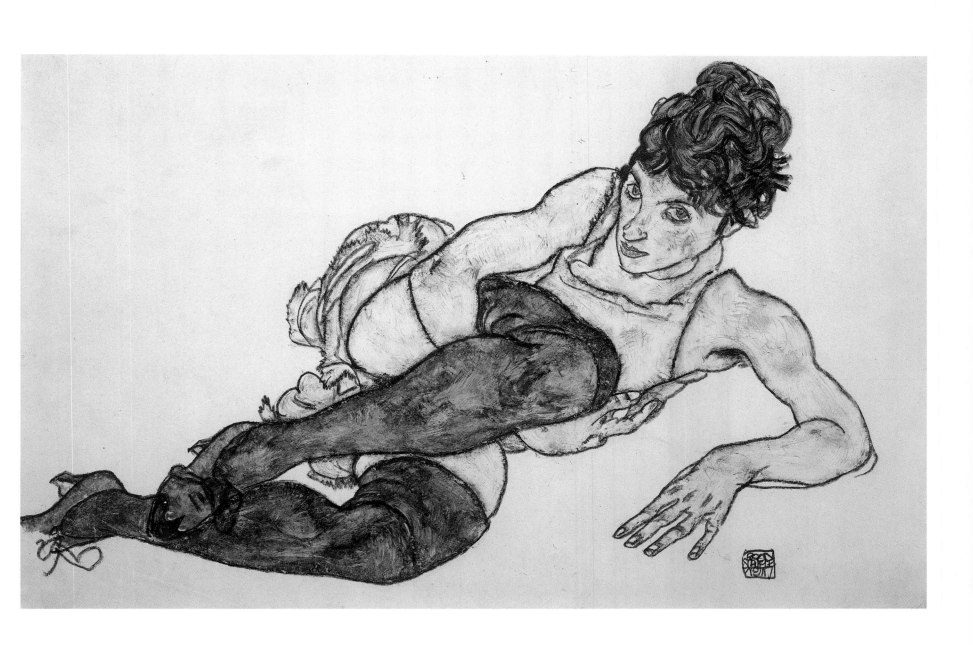

PLATE 24

Portrait of the Painter Paris von Gütersloh

1918. Oil on canvas, 55¼ x 43¼" (140.3 x 109.9 cm).
Signed and dated, lower right. Kallir P. 322.
The Minneapolis Institute of Arts, gift of the
P. D. McMillan Land Co., 1954

Schiele's drawings in the last years of his life came to rely more on contour and tone, but his painting style became, paradoxically, less linear. Although an armature of line was visible to the last, it was overshadowed by an increasingly robust network of expressive brushstrokes. Schiele was now fully capable of exploiting the traits intrinsic to oil. He wielded buttery impasto masterfully, rather than thinning the paint down in an attempt to mimic watercolor or pushing it around like gouache. It could almost be said that, at the very moment that he was becoming a classical realist in his drawings, Schiele was, for the first time, becoming a genuine Expressionist in his paintings.

In truth, many conflicting directions are suggested by Schiele's late works, and it is impossible to know which he would have pursued had he lived. The *Portrait of Paris von Gütersloh,* one of Schiele's last paintings, was probably begun in the spring of 1918, at the same time as a related lithograph (Kallir G. 16). Thought by some to be unfinished, the portrait invites several interesting hypotheses regarding the artist's aborted development.

Unlike Schiele's commissioned portraits, which can be a bit staid, the Gütersloh painting—of a longtime friend and fellow artist—is brimming with vitality. The direct stare of the early portraits (largely absent in Schiele's oils after 1915) here returns. As an artist, Gütersloh recalls Schiele's visionary alter ego. He is a man possessed, whose trembling fingers, held aloft like those of a surgeon preparing to operate, constitute the key to his supernatural powers. Schiele positioned Von Gütersloh in a self-contained world of paint. This is not the customary background void, but an all-embracing painterly fabric out of which the sitter organically emerges. One can only wonder whether the pictorial abandon of the Gütersloh portrait was merely the hallmark of a work in progress, or whether this brighter, bolder, almost abstract approach might have heralded Schiele's ultimate destiny.

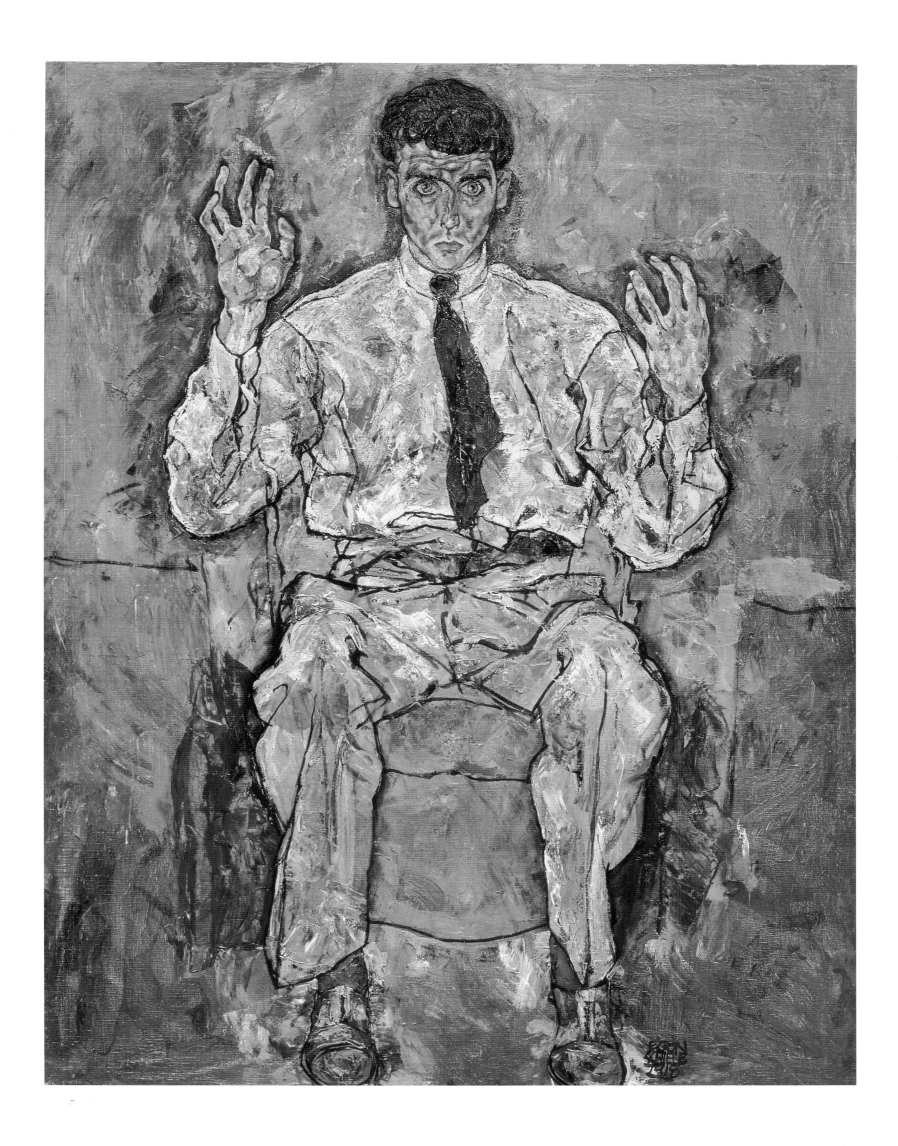

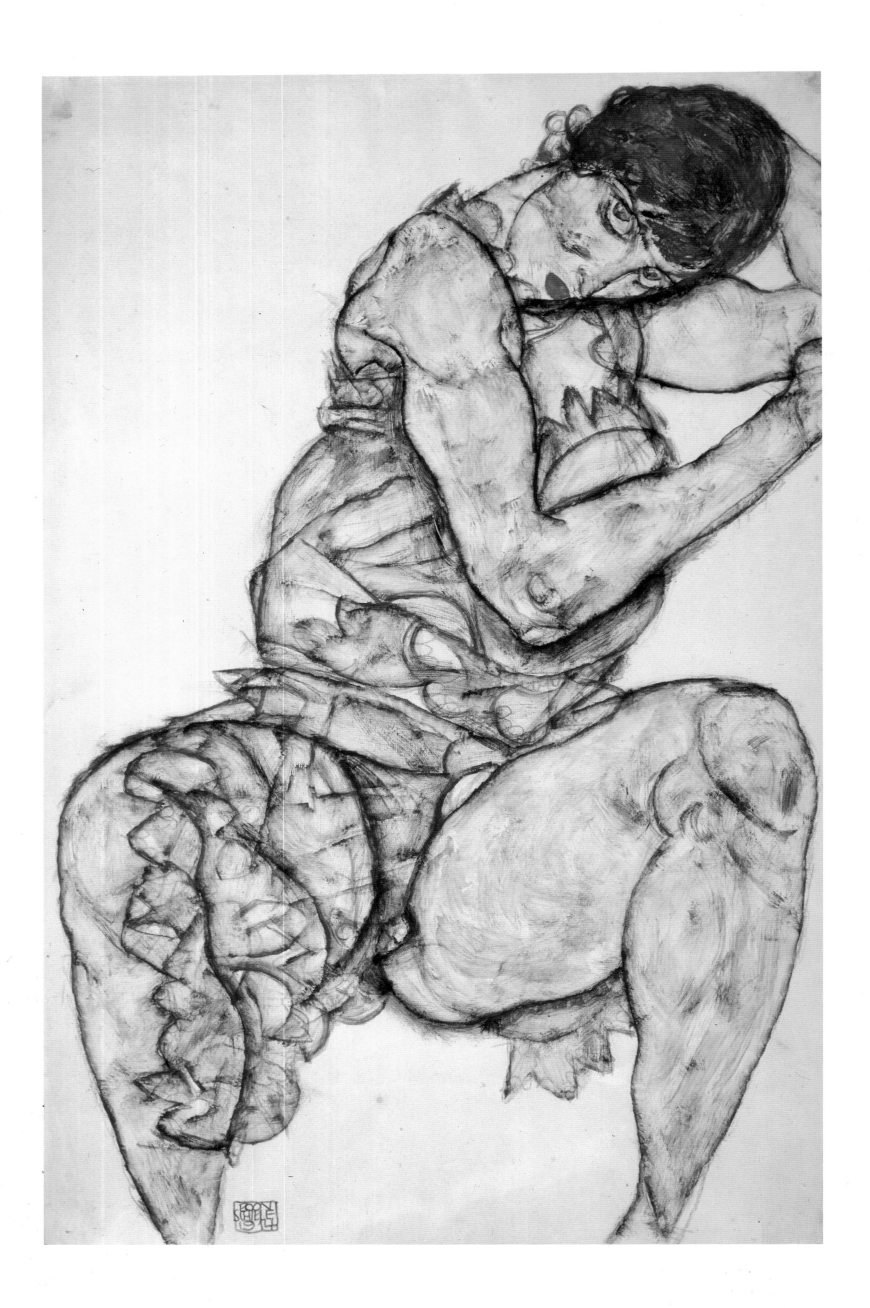